Sea Glass Chronicles

whispers from the past

Text by C.S. Lambert
Photographs by Pat Hanbery

Down East

Text © 2001 by C. S. Lambert
Photographs © 2001 by Pat Hanbery

Cover and interior design by Lindy Gifford

Printed in China

ISBN 978-0-89272-508-3

Library of Congress Control Number 2001090323

Acknowledgments

Considerable thanks to the following experts, collectors, institutions, and friends for their generous contributions to this book: Steve Battelle, Joan Beckerman, Jeanne Berger, the Camden Public Library, Mimi Carpenter, Don Carpentier, Lord Chamberlain's Office at Buckingham Palace, Mechele Cooper, Dave Conley, Amy Cornell, Chris Cornell, Jeff and Jo-Anne Crawford, Christie Cummins, Denise Donnelly, Steve Dumas, Lindy Gifford, Laura Gonzalez, Rebecca Green, Dave Gymburch, Lisa Hall, Erin Hanley, Terri Hibbard, John Bottero Holmes, Johnson PhotoImaging, Jackie Manning, Carol Martell, Greta Massey, Melanie McKeever, Prudy McMann, Warren Murphy, Cynthia Peckham, the Rockport Public Library, Steve Pendry, Esther and Chris Pullman, Irene Roy, Wyatt Shorey, Debbie Smith, Laura Sprague, Kaja Veilleux, Dorsy and Bill von Rosenvinge, Milly Walker, the Waterville Public Library, William Woys Weaver, the Wiscassett Public Library, Sandy Whitney, and Peter Woodruff.

To the memory of Slick, the parrot, who loved sea glass as much as we do.

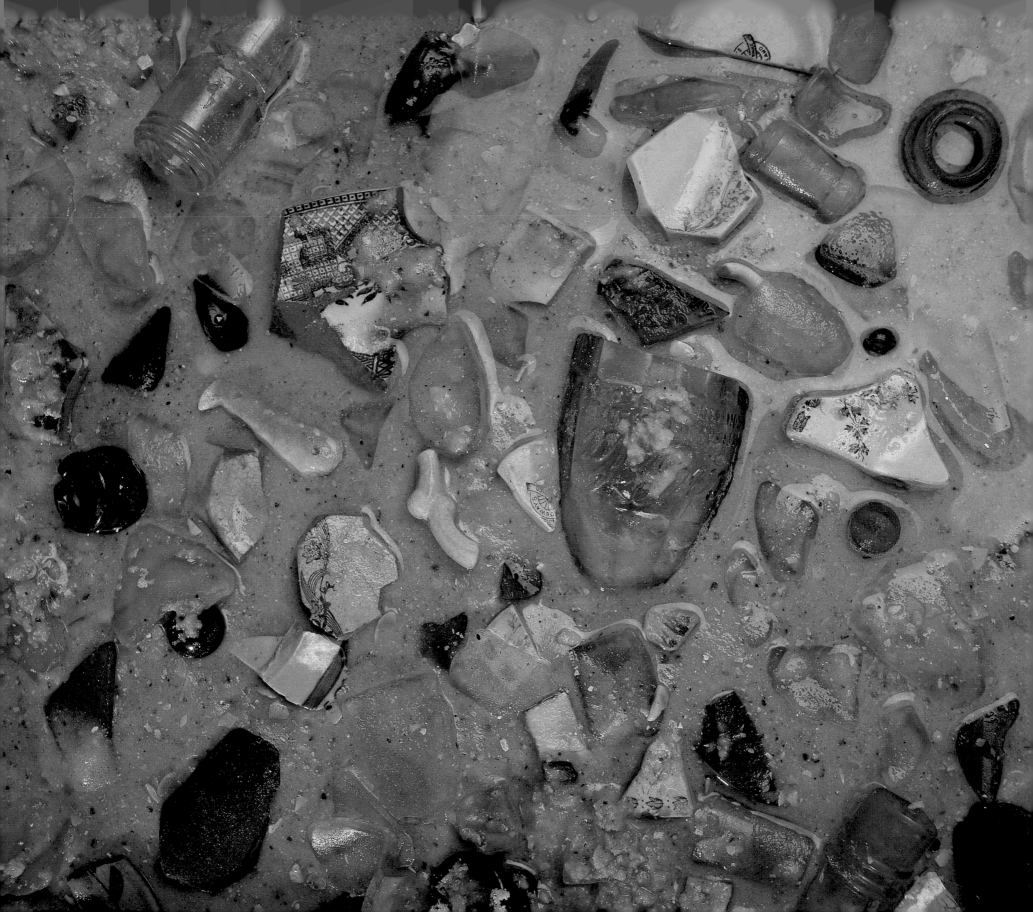

Prologue

Rich cargoes of ceramic and glass lie on the ocean bottom, the result of shipwrecks, piracy, and foul weather. The sea has also served as a dumping ground for all manner of garbage, including ceramics and glass, since the beginning of time.

Shattered by random forces of Nature, remnants have been carried offshore and back again, washing up on beaches throughout the world. These shards, known generically as sea glass or beach glass, acquire a smooth shape and a faded, or frosted, patina—the natural consequence of years, sometimes centuries of punishing waves and abrasive sand.

I remember the first time I found a pictorial ceramic shard. It forever changed my perception of sea glass. Wedged between two rocks at the end of a crescent-shaped beach, the white fragment caught my eye. It measured no larger than one inch by half an inch. Closer inspection of the surface revealed the faint image of a blue farmhouse with windows, fencing, a silo, and a barn roof. The minute detailing astounded me.

This piece of ceramic became art on its own terms. Its asymmetrical beauty had evolved out of untold travels, and its finely pocked surface offered a vignette from another time and place.

I began to speculate about other sea glass shards that I had amassed over the years. I started to uncover their identities in museums, the china closets of family and friends, flea markets, yard sales, libraries—wherever I saw whole pieces of glass and ceramics.

As I broadened my definition of sea glass, my searches became more discerning. And the more I looked, the more I found. Still today I am awestruck at the duplicitous fragility and strength inherent in these shards.

Like a time capsule, sea glass can reveal much about the people, places, and events that were linked to the original object, whether it was a teacup, apothecary bottle, or child's toy. Some shards speak more clearly than others, which steadfastly refuse to surrender their histories. And some pieces raise more questions than they answer. While it is impossible to trace the exact origins of many fragments, each reveals clues through its color, design, and composition.

Even those whose manufacture or usage will forever remain a mystery may recall ancient legends, which often sprang to life near the ocean. Other pieces may invite being tied to literature or to forgotten customs.

Almost every shoreline offers up worlds of adventure, archaeology, science, and the arts in the form of sea glass and ceramic shards. These discarded remains can pull the beachcomber through a passageway into history, one founded on documented research or one broadened and colored by the imagination.

Maybe that is part of the appeal and the romance of treasure hunting at the edge of the tide. For some, the secrets whispered by sea glass hold more riches than a pirate's chest.

Note: All the sea glass photographed herein is genuine; none has been tumbled, filed, colored, or modified in any way. Each fragment rolled up on a beach with the everyday lottery of tides, currents, and chance.

I Sand and Fire: Glass Shards

Strewn across an expanse of beach and glistening in the sunshine, a group of glass shards might be mistaken for jewels: sapphires, rubies, emeralds, topaz, and diamonds. Sometimes after a storm with strong onshore winds, a large volume of sea glass covers the sand. Then, and only rarely, retreating waves skim across the shards, dragging them seaward and creating a muffled clinking or tinkling sound.

A French abbot once remarked that colored glass could affect human perception, "urging us onward from the material to the immaterial." Like the windows at Saint-Denis, the church this abbot helped rebuild, sea glass draws a certain reverence.

To the uninitiated, though, it is often overlooked and dismissed as trash. Recently broken beer and soda bottles constitute the majority of fragments on many beaches, and their sharp edges pose a hazard to bare feet. Unfortunately this recycling *faux pas* has given a bad name to antique sea glass, the beachcomber's treasure.

Originally created from a molten mix of sand, soda, and lime, such glass has made an evolutionary journey that has come nearly full-circle. If left long enough, the shards will be broken down and turned back into sand.

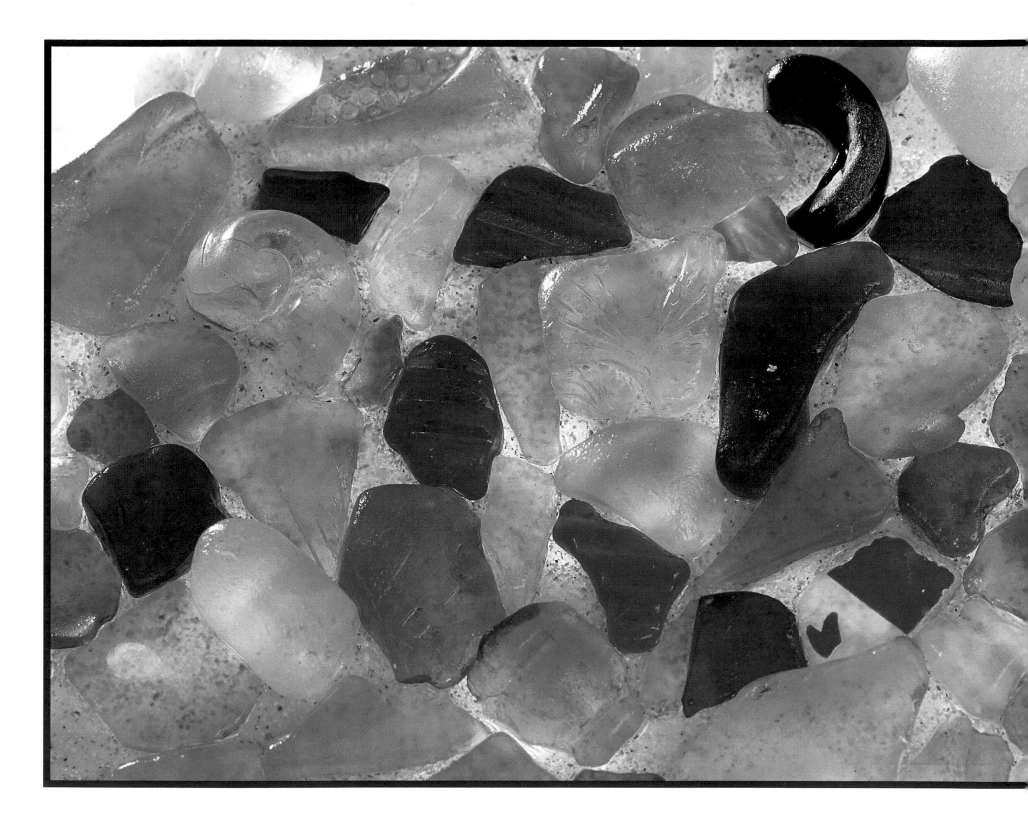

9

From the late Victorian period to around 1900, apothecary bottles were topped with matching glass stoppers such as those in this grouping of sea glass. Remarkably, a few remain whole.

Apothecary bottles in this style held the more expensive medicines, elixirs, and poisons, and were refilled rather than discarded. The stoppers were ground to fit snugly into the bottle necks. Less expensive drugs were sealed with cork stoppers.

The diameter of the largest stopper in this group measures approximately 1⅝".

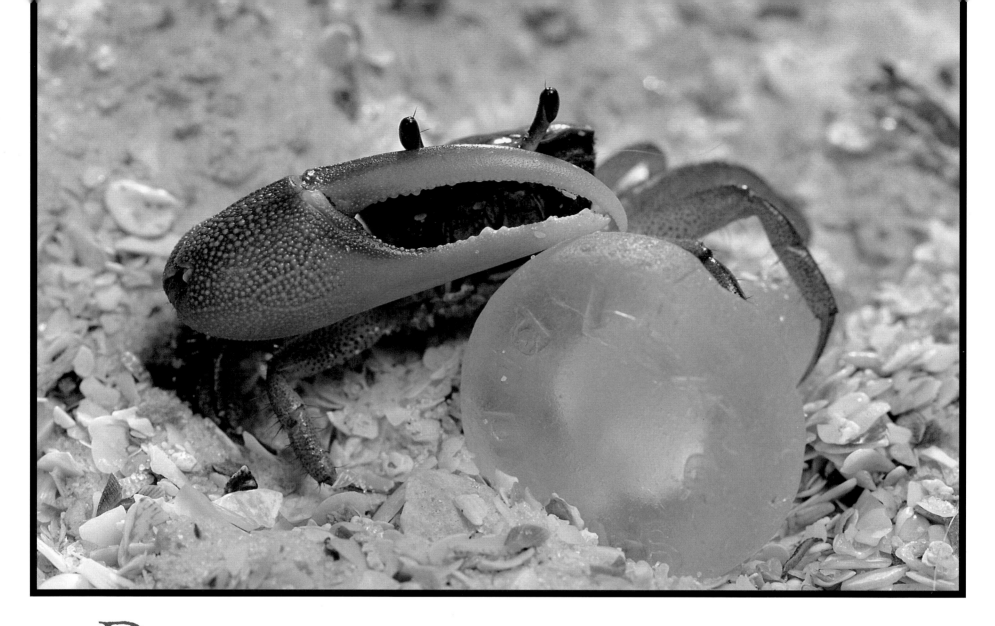

Dating from around 1876, this bottle stopper is linked to a tale of secrecy and intrigue that spanned three continents. According to Lea and Perrins, Inc., located in Fair Lawn, New Jersey, the origins of Worcestershire sauce are as follows: An English lord discovered an unusual recipe during his stint as governor of Bengal, India. Upon his return to his home in Worcester, England, in the early 1800s, he requested that the local chemists, John Lea and William Perrins, recreate the sauce.

But the combination of odd ingredients from around the world—tamarind, anchovies, chilies, peppercorns, molasses, garlic, onions, and cloves—resulted in an unpalatable liquid. So, the chemists relegated the concoction to basement storage, where it was forgotten. Eventually, though, the sauce was rediscovered. It turns out that aging was the key to the flavor discovered and cherished by the English lord.

The chemists bottled and distributed the condiment, and within a few years, Lea and Perrins Worcestershire sauce was known throughout Europe. Soon it gathered international acclaim, as well. The English lord, who was not invited to participate in the business venture, is, however, still saluted on the bottle's label, where the sauce is described as "the original and genuine, from the recipe of a nobleman in the county."

This early bottle stopper was made by the Salem Glass Works of Salem, New Jersey, for John Duncan and Sons, the wine and liquor importer who brought Lea and Perrins to the United States. The sand used to create the glass contained an iron impurity, resulting in its light green color.

This shard measures approximately 1⁵⁄₁₆" in length, and the diameter of the stopper's top is ⅞".

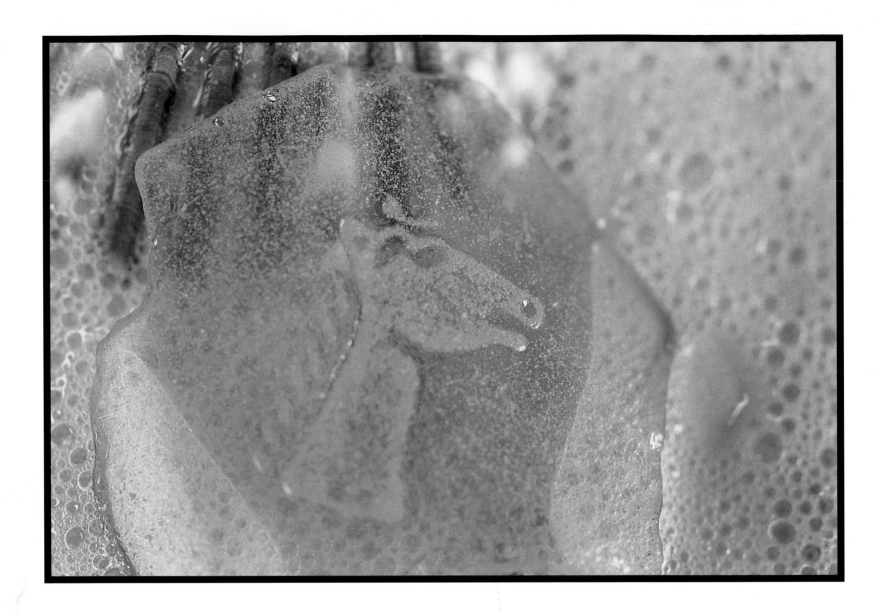

In early Irish legend, the foam on cresting
waves was known as "white horses." Every
seventh year on May 1, according to folk-
lore, an Irish chieftain named O'Donohue
rides his powerful white horse over the Killar-
ney lakes in search of his lost love. Fairies
reputedly toss flowers to pave his way across
the water's surface.

This bas-relief pony on green glass, perhaps
from a 1930s soda bottle, has doubtless ridden
with many a mythical herd.

This shard measures approximately 1½" by 1½".

Ranging from the deepest amethyst to the palest orchid, these rare pieces of sea glass cover the purple spectrum. Ironically, their color is simply the result of an unintended chemical reaction. Most of these shards originated as clear, uncolored glass that turned varying shades of purple when exposed to sunlight.

For thousands of years glassmakers have used a critical ingredient to produce clear glass. That element, manganese, masks the blues and greens resulting from iron impurities in the sand, soda, and lime in the formula. It does so by introducing the opposite colors—yellow, red, and purple—which yields glass with no color at all.

However, the glass is empurpled when exposed to the sun's ultraviolet rays. The lightness or darkness in its hue depends on the amount of manganese originally used in the mixture and on the length of time the glass has been exposed to sunshine.

The largest shard in this group measures approximately 1¼" by 2".

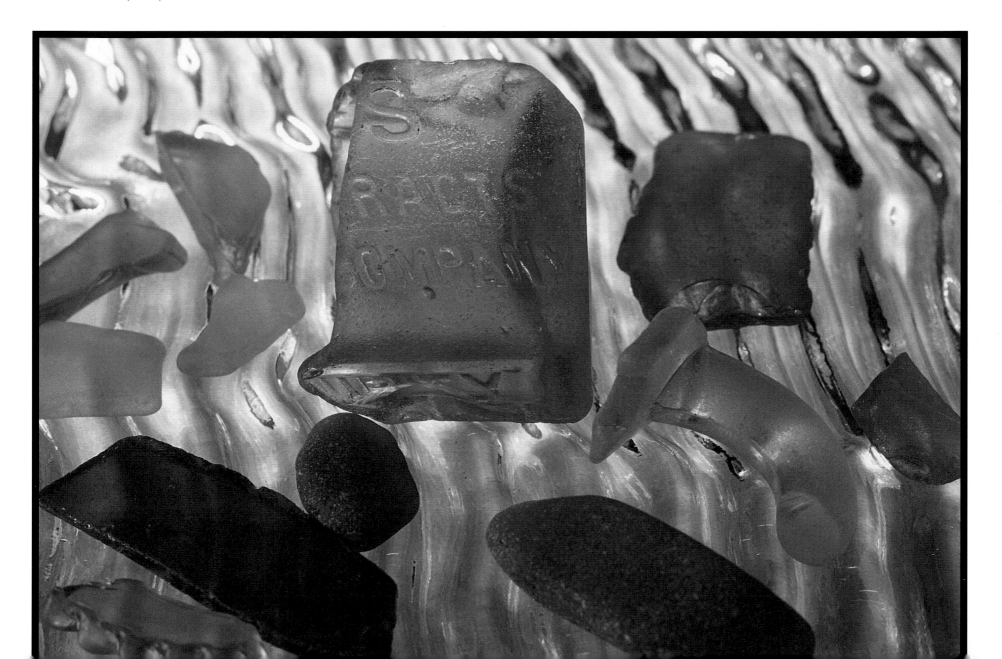

Predating today's plastic container, this garnet-colored shard bears partial letters from an early Clorox bottle.

The well-known bleach originally came in five-gallon crockery jugs that were delivered to industrial plants by horse and wagon as early as 1913.

Amber bottles were introduced to the public in 1918. Carbon or nickel created their brownish color. Curiously, not until 1933 did the fifteen-ounce container become a true pint bottle, holding sixteen ounces.

This fragment can be dated between 1929 and 1930 because of the diamond design element, which appeared as part of the trademark on the bottom of the bottles produced during those years.

Glass bottles were phased out in favor of plastic jugs in 1962.

This shard measures approximately 2¼" by 1½".

14

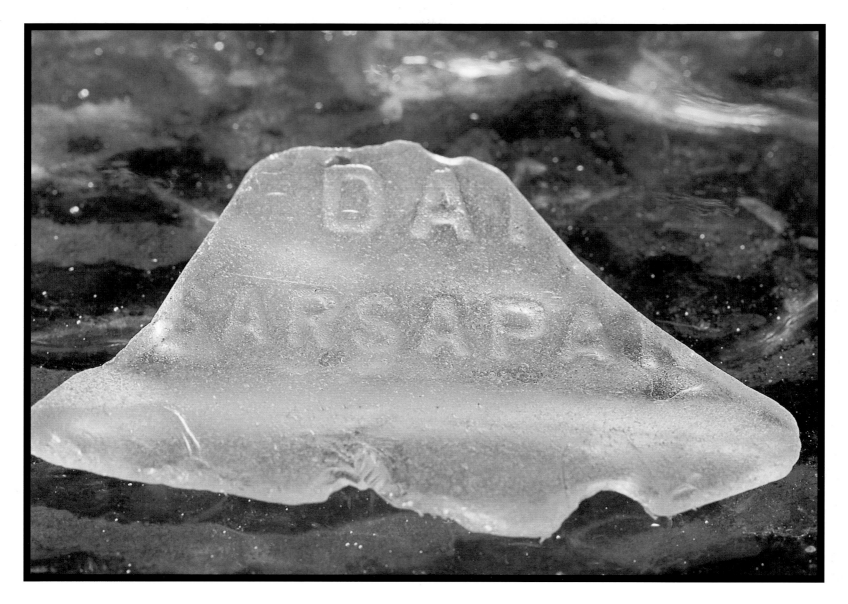

This sea glass once belonged to a bottle containing a nineteenth-century elixir. Sarsaparilla purportedly cured a variety of conditions such as boils, tumors, rheumatism, and syphilis. Doctors often recommended it as a tonic to be taken regularly because they believed it cleansed and purified the blood. A sample recipe included the dried roots of the smilax vine; alcohol; dandelion, yellow dock, or burdock roots; and prickly ash, birch, or sassafras bark.

Modified versions of this formula are used today to flavor medicine and soft drinks.

The raised lettering on this shard identifies it as Dana's Sarsaparilla, manufactured in Belfast, Maine.

The shard measures approximately 3" by 1½".

15

While some of their pressed or etched detail has been buffed smooth by Nature, these delicate bits of sea glass represent artifactual signposts of the Victorian era. They once sat atop fashionable perfume bottles containing fragrances such as rose and violet. Now far from the dressing rooms where they were treasured, they recall a time when bathing was not a daily occurrence.

The smaller stoppers, which might have been mounted in silver, belonged to scent bottles that were carried in beaded handbags. In close quarters, these small containers could be whipped out and their contents sprinkled on a kerchief in order to counteract the pungent body odors of others. And in an age of wasp-waisted dresses, when swooning was a hazard of fashion, a small vial containing ammonia or smelling salts came in handy.

The smallest stopper measures ⅝" in length.

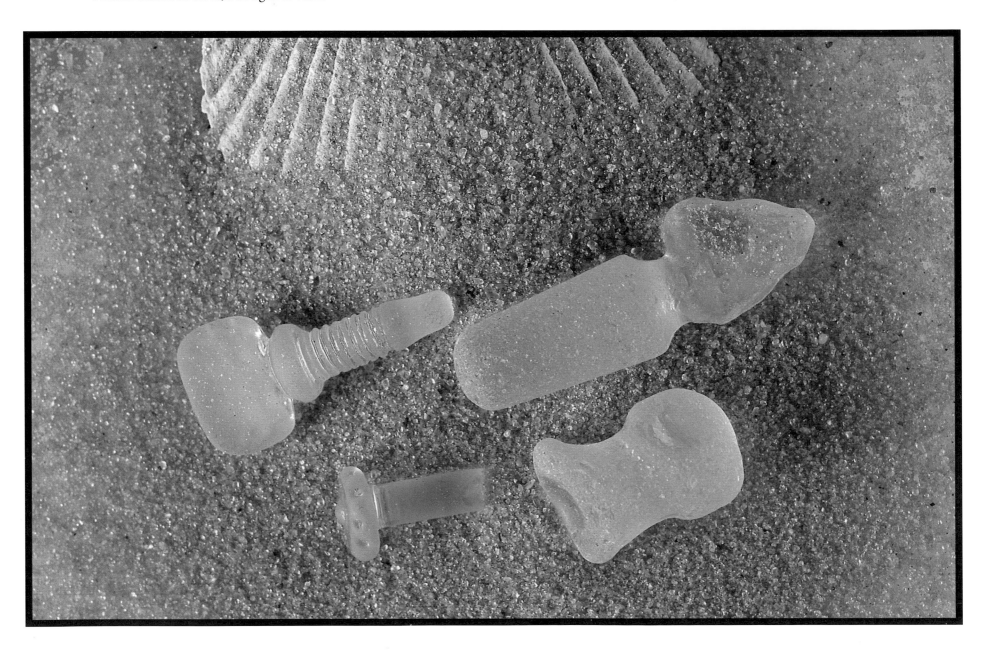

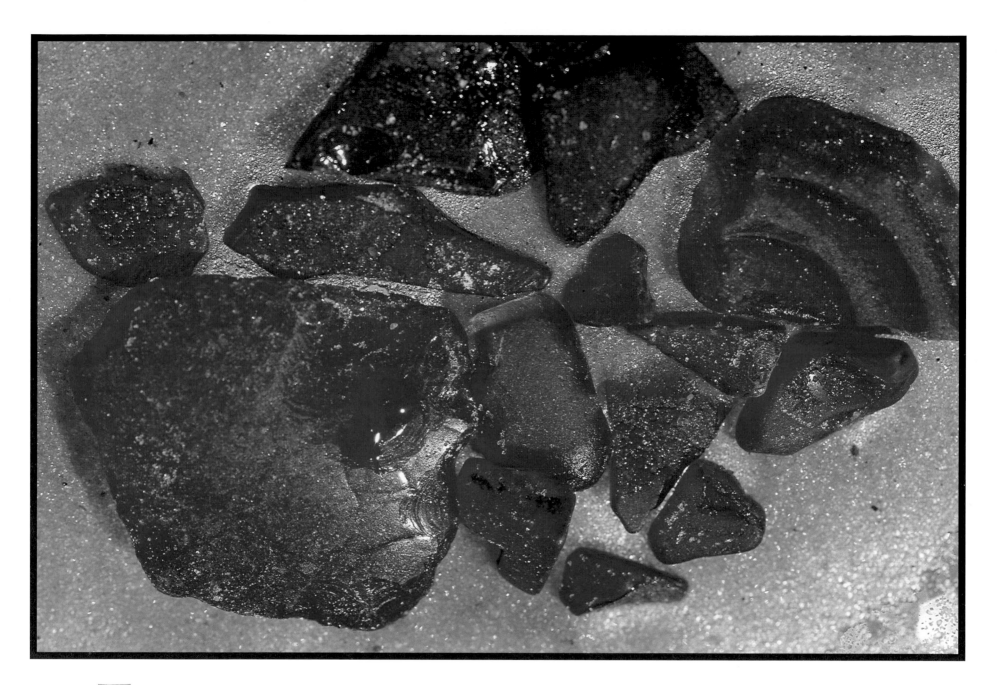

Forget the common diamond- and topaz-colored sea glass; ruby red is the gold standard, literally. Its scarcity and value owe to a key ingredient—gold. For example, sixty pounds of ruby red glass contain a full ounce of the precious metal.

The largest shard in this group measures approximately ¾" by 1".

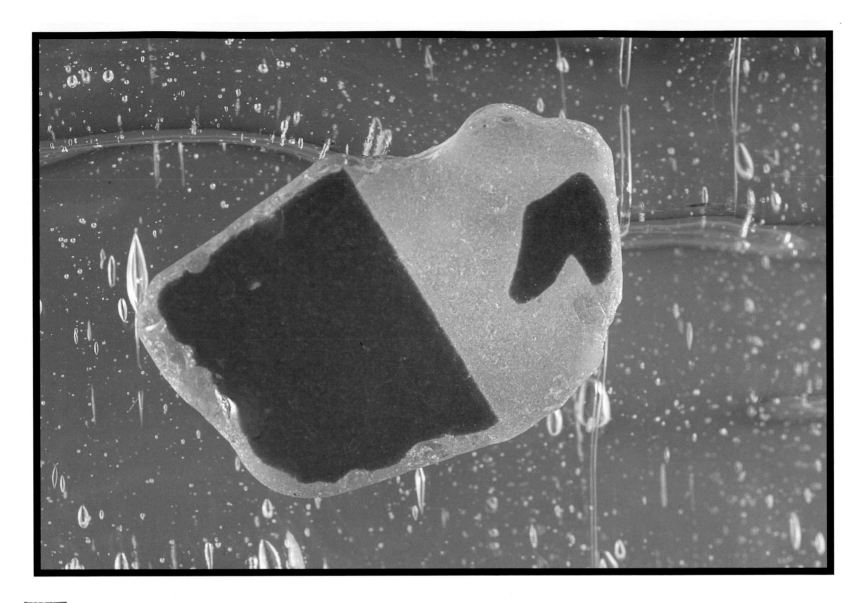

This shard of delicate blue and frosted white hails from France and the Art Deco period. Known as cameo glass, the piece reveals a twentieth-century embellishing technique that developed out of an ancient Roman art form.

Originally, artisans fused one layer of glass to another layer of a different hue. Then, inspired by shell cameos, they carved through the layers to create the desired shapes.

Eventually, a less expensive and less time-consuming method of creating the cameo effect evolved. Instead of overlaying glass with glass, modern craftsmen "flashed" the initial glass surface with paint of a second color and then scratched out a design. This shard shows that more recent method.

This shard measures approximately 1" by ½".

apphire sea glass reverberates with the varying shades of the ocean. Here, as evidenced by footprints, a curious gull investigated this winter collection of blue shards.

While it is impossible to pinpoint when this colorant was first used, archaeologists discovered a piece of cobalt blue glass in the tomb of Tutankhamen. Porcelain from the Tang Dynasty (616-906) and Ming Dynasty (1368-1644) was also sometimes decorated with cobalt.

Many of these sea-glass shards came from less noble origins such as medicine bottles and cold-cream jars.

The largest shard in this group measures approximately 1" by ¾".

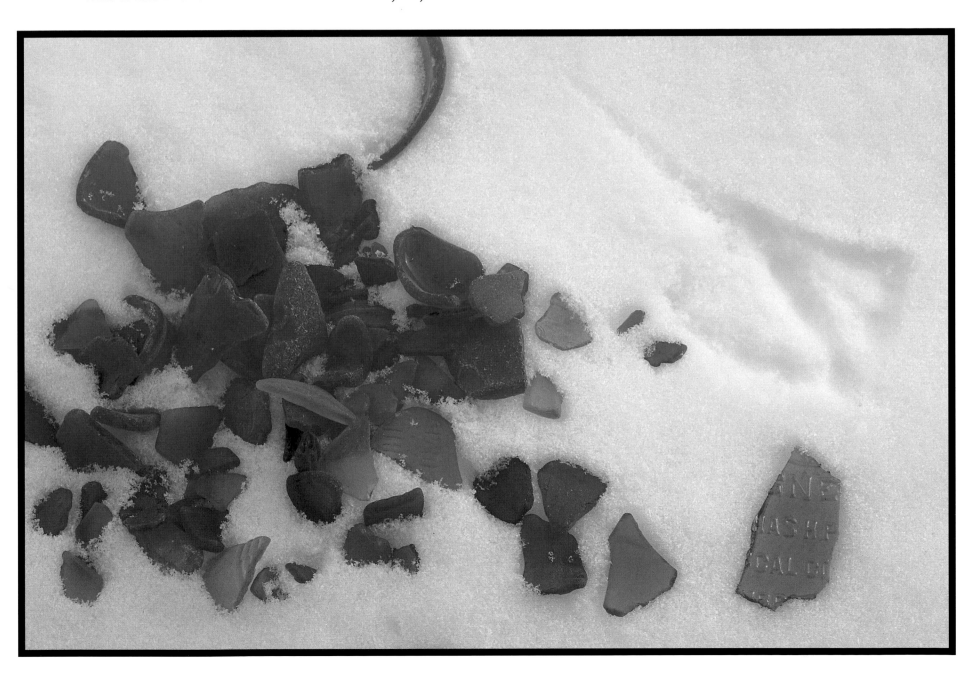

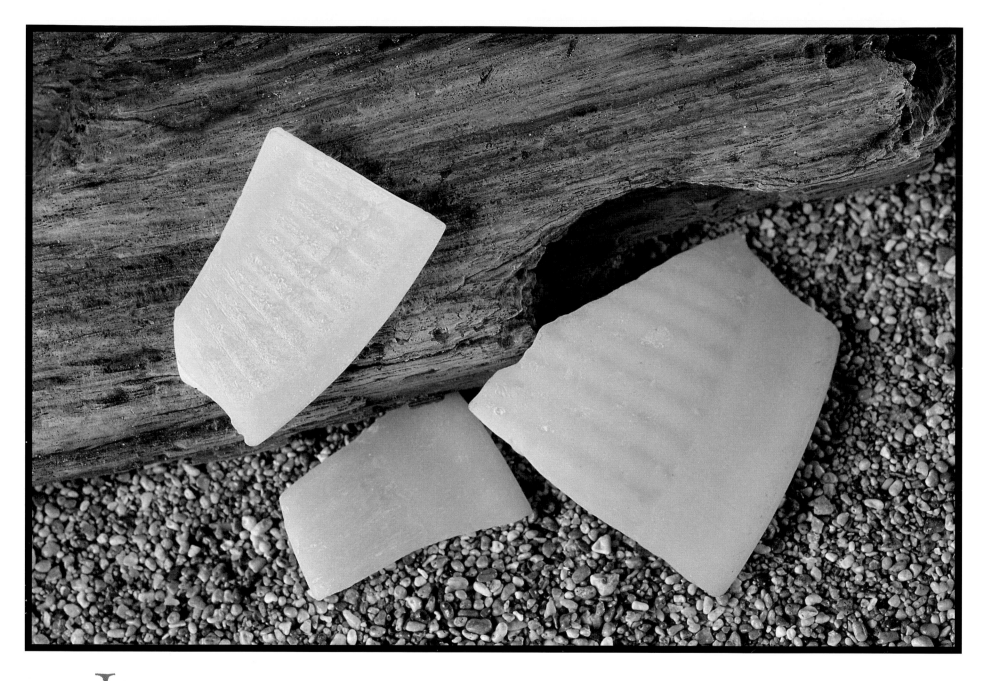

Jadite, an opaque green glassware made primarily between the 1930s and the 1970s, is experiencing a renaissance due to the interest stirred up by the ubiquitous Martha Stewart. Jadite pervades her books, television show, and magazine, where the glassware is sometimes a featured item. Elsewhere, it merely hovers in the background radiating subliminal messages.

Numerous glass manufacturers have mass-produced versions of jadite, and these appear in an array of kitchen and household items from mixing bowls to ashtrays, lamps to towel bars.

The larger shard measures approximately 1¼" by 1¾".

20

Known as the "Slenderizing Girl," the curvaceous beauty on this emerald green shard became a 1930s merchandising hallmark. Promotional materials boasted: "Burn that Adipose. That's the way to slenderize. 7Up is the spark that fires the body sugar that burns and melts away the fat. So 7Up Slenderizes." The company founder's son, H. C. Grigg, created this trademark design, among others.

Introduced in 1929 with the unwieldy name of Bib-Label Lithiated Lemon-Lime Soda, the carbonated beverage did contain fewer calories than its competitors. The seven bubbles in the logo's design were intergral to the advertising claims: "Seven natural flavors blended into a savory, flavory drink with a real wallop." One of the earliest slogans recommended "7Up for 7 Hangovers." Another said, "7Up alkalizes and corrects acid conditions. It normalizes and sweetens the stomach."

Due to what was called the "maturing" of the company, the Slenderizing Girl had lost her place in the corporation's marketing strategy by the late 1930s.

This shard measures approximately 1¾" by 2½".

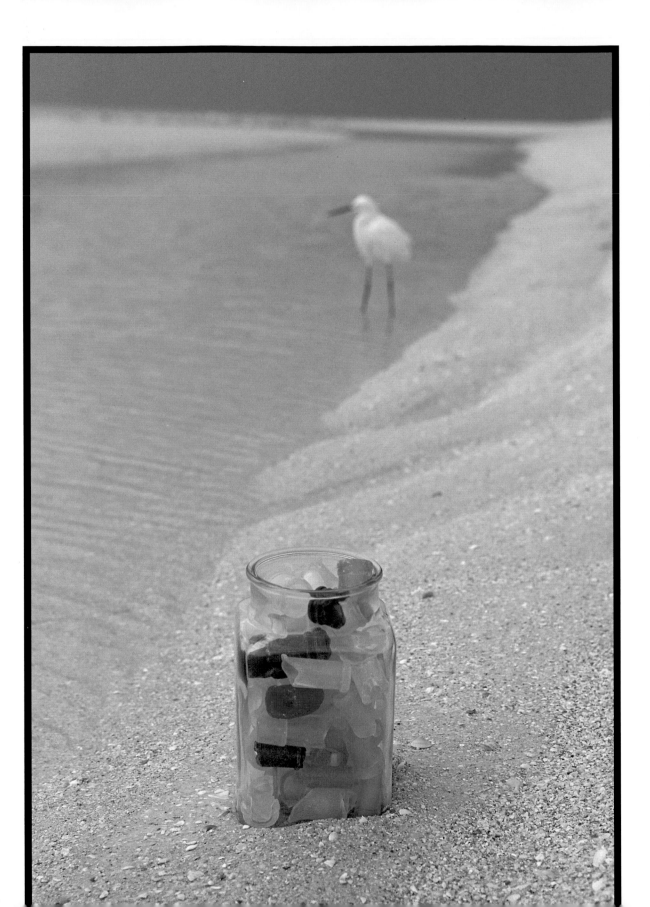

Because of its translucent qualities, sea glass is often housed in bottles or jars and placed on windowsills. Here, a collection of well-traveled bottlenecks have found a home in a candy jar.

The average shard in this grouping measures approximately 1½" long.

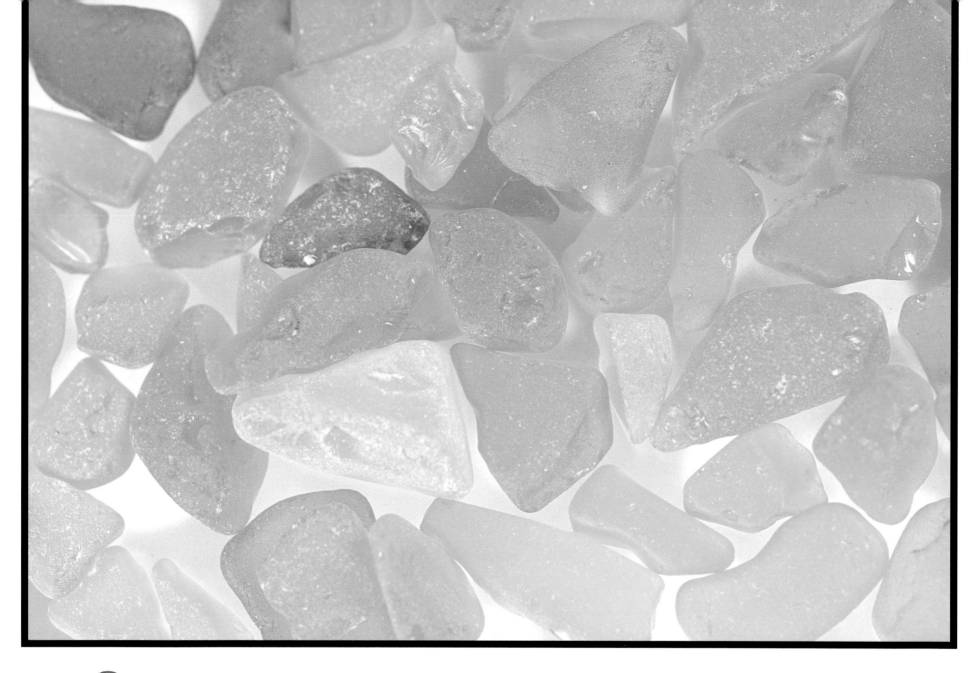

Some beachcombers call them emeralds. Others think of them as the world's finest jade. Still another notion is deeply rooted in sea lore and perpetuated by writer and artist Mimi Carpenter in her book *Of Lucky Pebbles and Mermaid's Tears.* An excerpt:

On a beautiful island called Islesboro
Just below the edge of low tide,
Lived a mischievous Mermaid named Shorah
With the Sea Ugly Xyat by her side.

She was different from all of the others,
Wearing fins on her nose and her ears,
But the most remarkable things you would notice
Were her scales—and her soft green, glass tears.

The real origin of green glass is, of course, less romantic. It is created with chromium, copper, and iron.

The largest shard in this group measures
approximately 1¼" by ⅞".

23

Trapped in the icy surf, this white-flecked turquoise shard might have begun its long journey in England. The Nailsea Crown Glass and Bottle Manufacturers opened in Nailsea (near Bristol) in 1788, specializing in bottles and windows.

At the end of the work day, glassworkers combined the molten remnants to produce useful and whimsical items such as hats, walking sticks, pipes, hunting horns, cruets, and rolling pins for their families. The terms "end-of-day glass" and "Nailsea-type glass" still apply to sturdy, colored glass objects that are flecked or trailed with white.

This fragment was probably made between 1790 and 1830—at the height of popularity for end-of-day glass in England. The curved inner rim suggests that it was the base of a water pitcher or jug.

This shard measures approximately 2½" by 2".

Two clues unveil the identity of this unusual sea-glass shard: Its fluted edge suggests that it came from a "bride's basket," and its coloring—pink with silver speckles—dates it as late 1800s "end-of-day" glass.

Traditionally, artisans created "end-of-day glass" on their own time and utilized materials that would have otherwise been discarded. The technique of combing or splashing one color of molten glass onto a cooling glass surface of another color originated centuries prior to the birth of Christ.

Brides' baskets were often multicolored, and some of them were supported by silver holders. Among the most popular gifts for Victorian-era newlyweds, these tokens of affection weren't considered fashionable after the turn of the century.

This shard measures approximately ¾" by ½".

Once globs of molten lead, these weathered fragments grew out of glassblowers' pipes. They are called kickups or dimples.

Each solid indentation once anchored the base of a wine or rum bottle. Dark green was believed to keep spirits from spoiling, and some bottle manufacturers added iron slag to the molten glass in order to achieve a darker, almost black shade. Kickups were created to provide extra strength.

The larger shards still retain some of the bottles' outer edges. Their rounded bottoms suggest that they originated in the eighteenth century.

*The smallest shard measures approximately ¾"
at its base.*

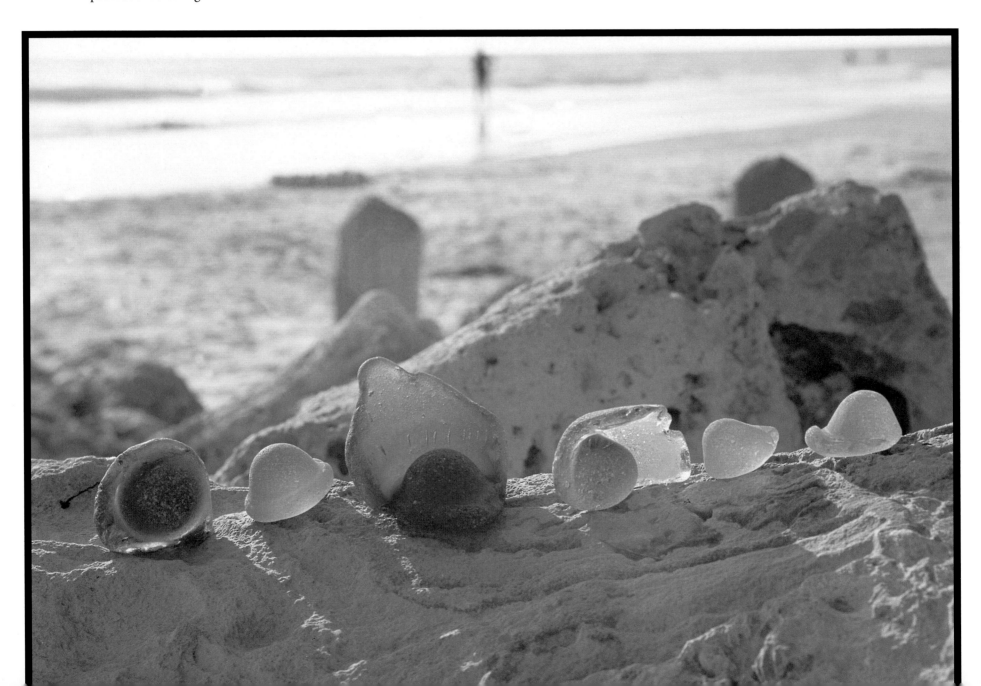

For all those who sniff that sea glass is worthless trash, these shards are highly prized in the world of fashion. Time and again when the natural look resurfaces as a trend, designers such as Calvin Klein adorn their models in naturally shaped sea-glass rings.

These bottle lips originated from a variety of sources. Common to early mineral-water containers, the one on the far right is known as a "blob-top," due to its shape.

The largest shard in this group measures approximately 1" wide.

If ever a successful marketing concept existed, it is found in these bits of sea glass. Nearly a hundred years ago, the Coca-Cola Company designed a bottle that "a person could recognize . . . when feeling it in the dark, so shaped that, even if broken, a person could tell at a glance what it was."

The distinctive contoured shape, created to best competitors who were using the generic, straight-sided glass bottles of the day, was invented by two supervisors at the Root Glass Company of Terre Haute, Indiana. The design is said to reflect a cocoa bean pod. But according to an article in *Communication Arts* magazine, "the undulating shape of the Coke bottle is similar to the highly stylized statuettes of female deities produced by Greek and Cyclic artists in the period between 2500 and 2000 BC."

All of these shards can be dated prior to 1957 because of the embossed lettering, which was replaced by white "applied color labeling" in that year. Size offers another clue to the age of these fragments. Considering the deduced circumference, the majority of these shards originated before 1955. The bottles were larger than the original six-and-a-half-ounce versions introduced that year.

The color, known as "Georgia green," is another unmistakable characteristic of the hobble-skirted bottles.

The largest shard in this group measures 3½" by 2".

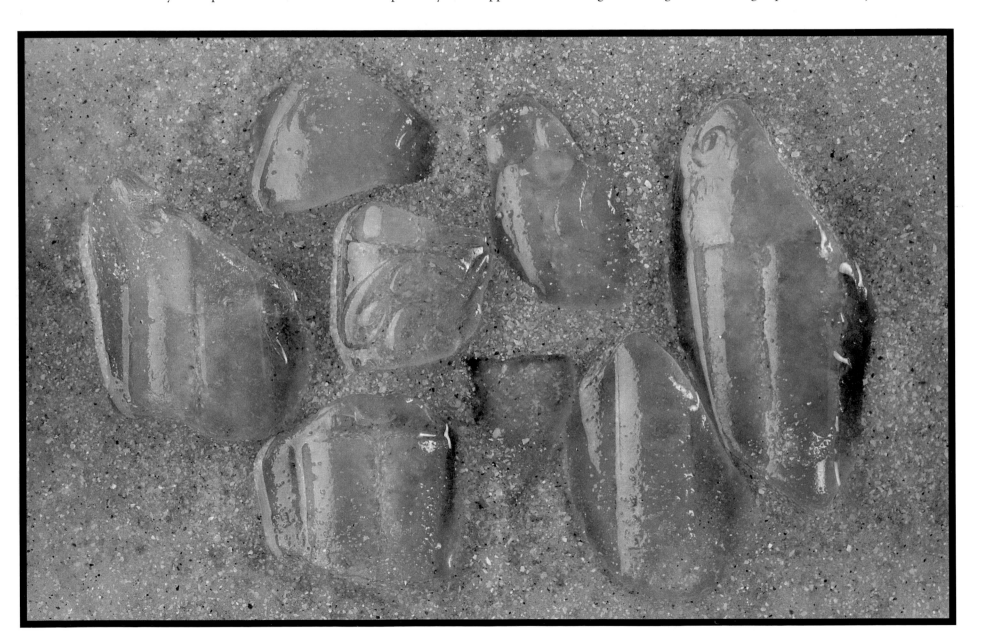

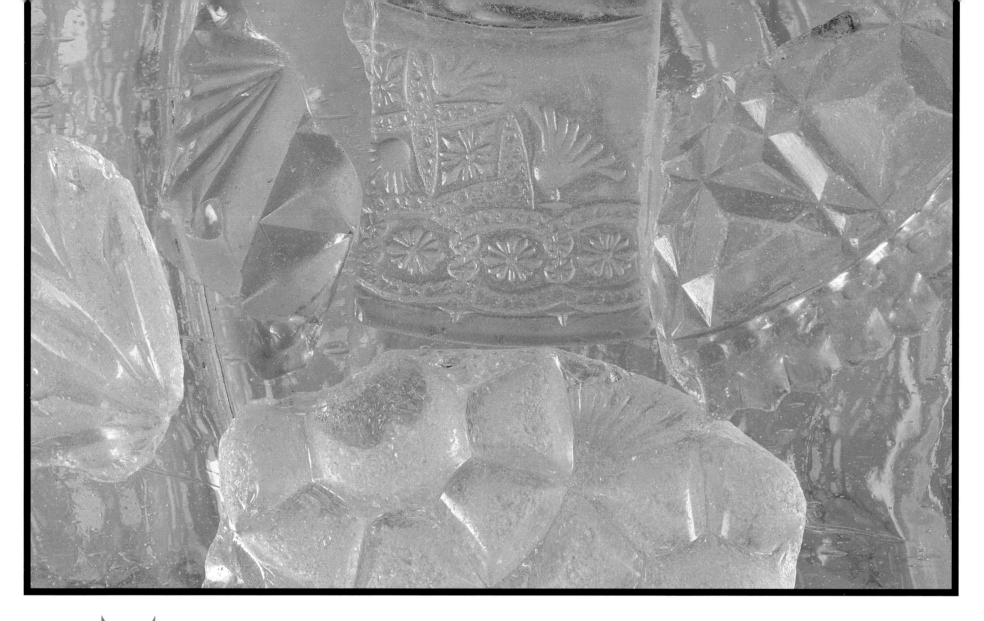

More akin to rhinestones than dia-monds, these shards bear the blunt edges and mold lines that are characteristic of pressed glass. This mass-produced 1820s invention filled a need for inexpensive tableware, decorative vessels, and even Gothic Revival windowpanes. Sandwich, Massachusetts, boasted the largest pressed-glass factory until its closure in 1888. Today, nearly two hundred years later, the product is still widely manufactured.

These shards represent part of the evolu-tionary story. From its inception and through the 1850s, heavy glass with simple designs prevailed. More elaborate geometrics domi-nated the market until the late 1860s, and by the 1870s, Nature inspired the patterns. Later, pressed glass took on a "lacy" appearance. More facets were also added to better reflect light and to more closely resemble finer cut glass.

The largest shard measures approximately 2¼" by 1½".

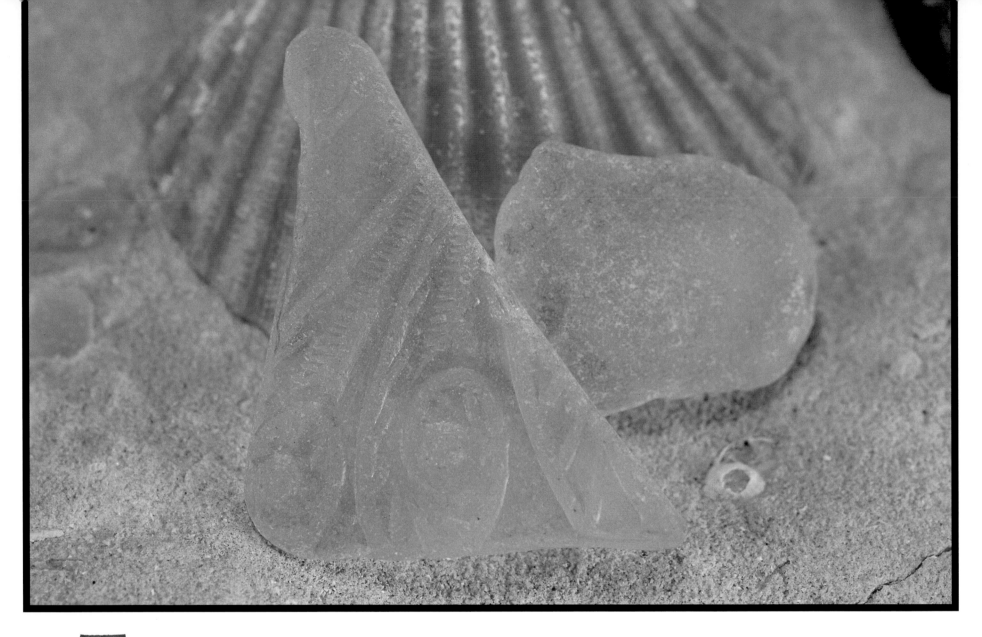

These orange pink fragments of depression glass seemingly find camouflage against a similarly colored sea shell. Originating in the 1920s with several manufacturers in America's midwest, this type of glass reflects the austerity of postwar American life. It is thin, inexpensive, machine-made pressed glass. Some of the patterns reflect nineteenth-century designs, while others take on the angles and curves characteristic of the Art Deco period.

The smallest shard measures approximately ½"

This exquisitely rendered piece demonstrates both the delicacy and strength of glass. Except for a few chips, the amethyst-colored perfume stopper somehow remained intact despite the ravages of the sea.

Its square top was molded and pressed in the Art Nouveau style. Dating from around 1910 to 1917, this perfume dauber was created by the French glass manufacturer Lalique.

This shard measures approximately 2 ¾" long with a ¾" head.

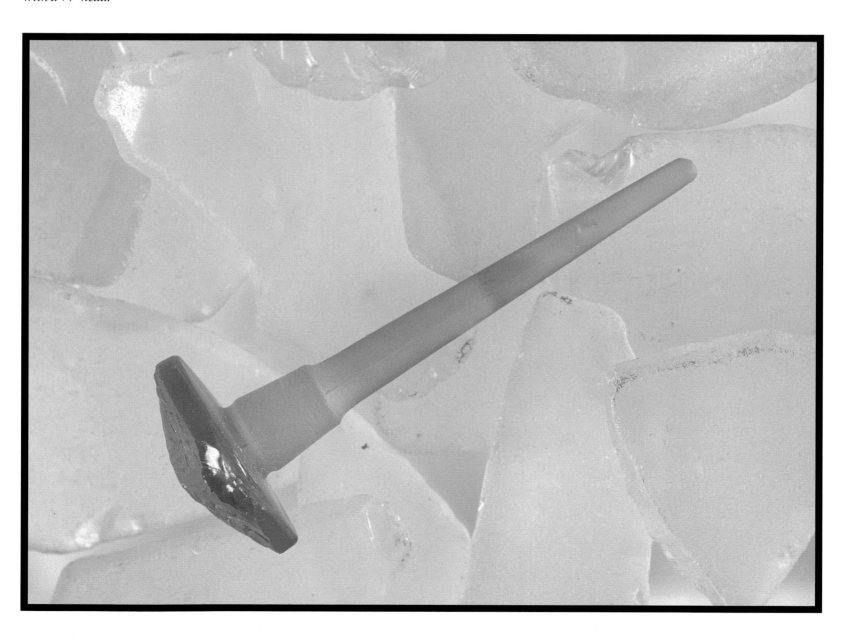

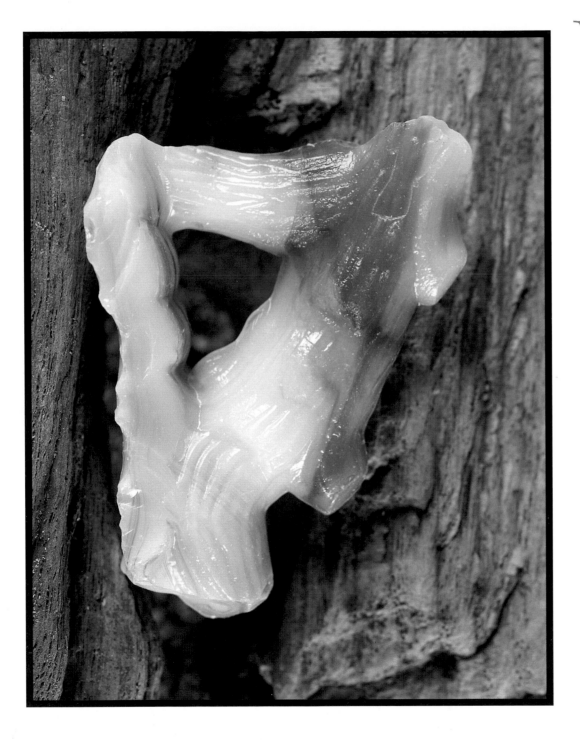

With colors that are reminiscent of a raspberry swirl pudding, this piece represents the genre known as "slag glass," which was also called "marble glass" because a second color runs through the white substrate. Slag glass is always opaque and is most often white with purple marbling.

This shard, probably a cruet handle from the 1890s, originated in America or England.

This shard measures approximately $1\frac{7}{8}"$ by $\frac{3}{4}"$.

Mounds of shattered beer, wine, and liquor bottles seem to shore up the pilings under a popular coastal tavern. Is this a sea-glass hunter's dream or an ecologist's nightmare?

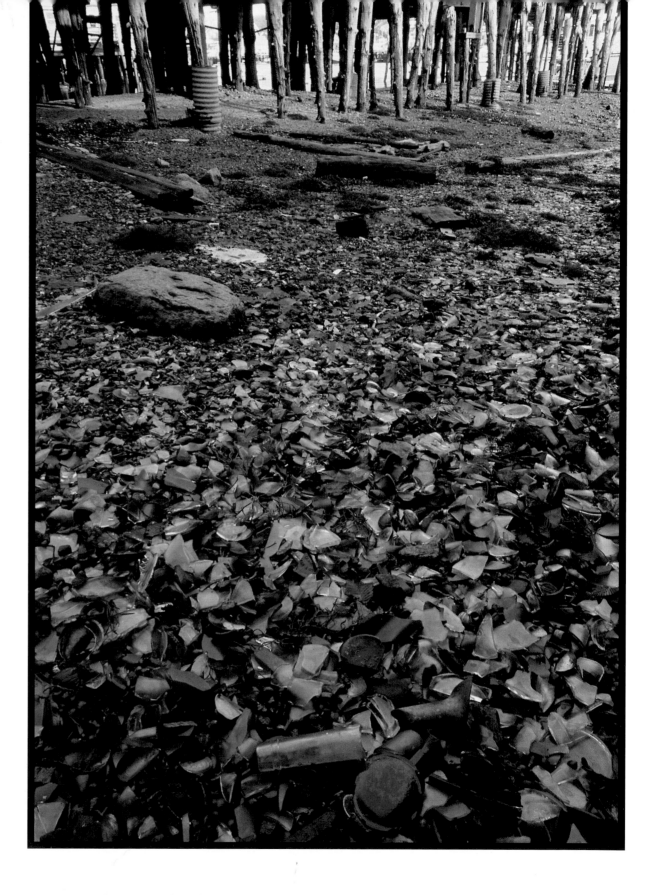

II Strangers in the Potter's Field: Ceramic Shards

Perhaps the most stunning examples of sea glass are not "glass" at all but fragments from the world's leading ceramic manufacturers. Some appear to be miniature works of art, broken in a way that reveals segments of lavish pastoral scenes and exotic motifs. Others bear floral and geometric patterns. The rarest masterpieces are inhabited by tiny images of people strolling in front of castles and animals roaming mountainsides.

Casual beachcombers commonly overlook ceramic shards, probably because the lackluster surfaces don't cry out as do those of sparkling, jewel-toned sea glass. Lost images lie incognito among similarly colored shells and pebbles. More often than not, as Murphy's Law seems to apply here, the scenic fragments lie face down in the sand, each concealing its own microcosm.

Pottery-making ranks among man's earliest artistic achievements. The medium encompasses a broad range of ceramics and includes porcelain, china, bisque, stoneware, and earthenware. Some of the fragments depicted in this section once belonged to the finest porcelain teacups, as well as to everyday dinnerware, crocks, earthenware jugs, and clay pipes. As sea glass they converge on subjects as diverse as horse racing, the Order of the Garter, and a Swedish opera singer.

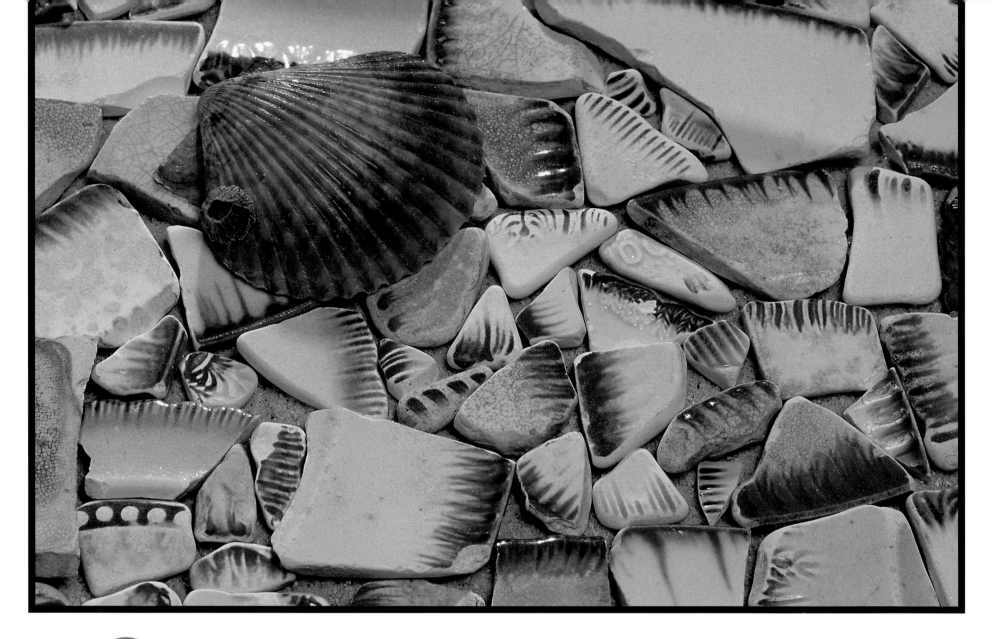

Created in the mid-1700s, the shell edge became one of England's most popular ceramic patterns. Reminiscent of the asymmetric rococo designs of continental Europe, the shell edge focuses the eye on the food rather than the plate's design. Josia Wedgwood, who is credited as one of the first Staffordshire potters to use the shell-edge pattern, began a trend that led more than fifty leading British potters to incorporate the motif into their designs. The style evolved over a period of nearly one hundred years.

Around 1800, the asymmetrical scallops of the shell-edge design became symmetrical. Embossed flowers, garlands, feathers, and wheat added to the pattern's transformation in the 1820s, and by the 1840s, impressed lines had replaced the scalloped rim. Finally, in the early twentieth century, the rococo asymmetry reappeared in the design. Exported in large quantities, the pattern was executed in brown, purple, red, and black, but blue and green were the most popular colors.

A testament to one of the most long-lived ceramic styles ever manufactured in England, shell-edge ceramics have been found at most eighteenth- and early nineteenth-century archaeological sites in America, as well as on beaches everywhere.

The average measurement of these shards is approximately 1" by ¾".

Land, sea, air, and people. This shard has it all. The two figures in the forefront bear a distinctly European style, and the surrounding architectural elements, combined with the indeterminate mountains, contain the lure of an illustrated travelogue.

The finely detailed imagery on this shard embodies a technique that revolutionized the ceramics industry. In the process known as transfer printing, designs were engraved onto copper plates, then transferred to paper. The paper was then pressed onto soft-paste porcelain and pottery before the pieces were fired. Not only were details easily reproduced, but due to the flexibility of paper, images could be applied to both curved and flat surfaces. Introduced in mid-eighteenth-century England, transferware proved both inexpensive and durable.

This unidentified fragment, probably English, originated after 1810, when stipple engraving, which created finer line variations, was introduced. Note the tiny dotted lines throughout the design, especially in the mountains and clouds.

This shard measures approximately 1⅛" by 1⅝".

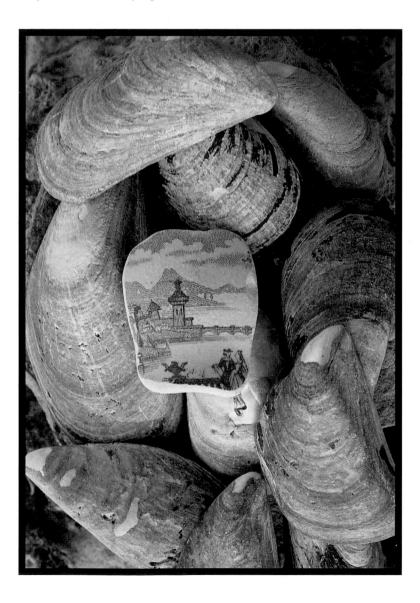

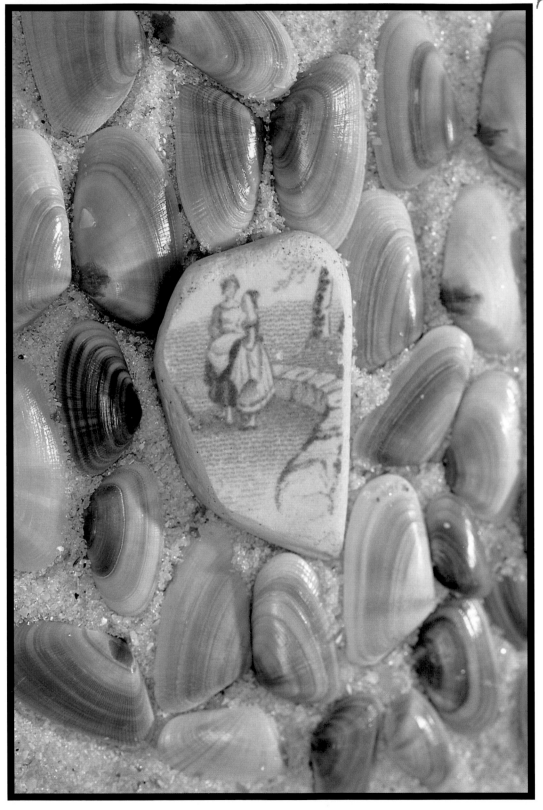

Two women stroll down a cobbled path edged by a stone wall. The mist, rising from the sea in the distance, hangs on the air with a palpable saltiness. Dressed in Victorian frocks, the women seem to stop mid-stride, transfixed.

This image is a diminutive portrait disconnected from a larger story—a scene on an English transferware plate. J. Clementson from England's Staffordshire region produced two patterns that contain this image—one known as "Tessino" and the other as "Loretto."

The artist who executed this design will probably never be known. Since England's Registration of Designs Act was not enforced until 1842, illustrations used in transferware were taken freely from any source and without acknowledgment. Most of the engravers, who contributed their own creativity in transferring the original artist's concept to pottery, were anonymous. The resulting illustrations were a combination of plagiarism and imagination.

It is known, however, that English potters borrowed heavily from the works of French painter Antoine Watteau (1648–1721) and English portraitist and landscape painter Thomas Gainsborough (1727–1788). In fact, impressionist painter Pierre August Renoir (1841–1919) apprenticed as a porcelain decorator in France at age thirteen.

This shard measures approximately 1½" by 1⅞".

Whether it was employed for storing, cooking, fermenting, preserving, or serving food, stoneware was indispensable in the majority of eighteenth- and nineteenth-century kitchens. These shards once belonged to crockery that held delights such as pickled vegetables, stewed fruits, and preserved meats.

According to food historian William Woys Weaver, author of *America Eats: Forms of Edible Folk Art,* "Early American potters seem to have captured all the subtleties of garden soils, brown sugars, and thick preserves in the very colors of their clays.

"From black jam pots to brown ketchup bottles, vintage pottery represents different types of garden soil: the black bottomlands of northern Ohio, the yellow loams of Kansas and Iowa, the gray clays of New England. To me, they embody the multitude of Early American gardens and the broad range of recipes that came out of them."

Today, a briny tinge still lingers in some pickle-crock fragments, and an air of musky spice survives in fruit-jar shards. Many stoneware pieces carry the balmy scent of potters' clay laced with some long-lost ingredient from another century.

The largest shard measures about 4¼" by 3".

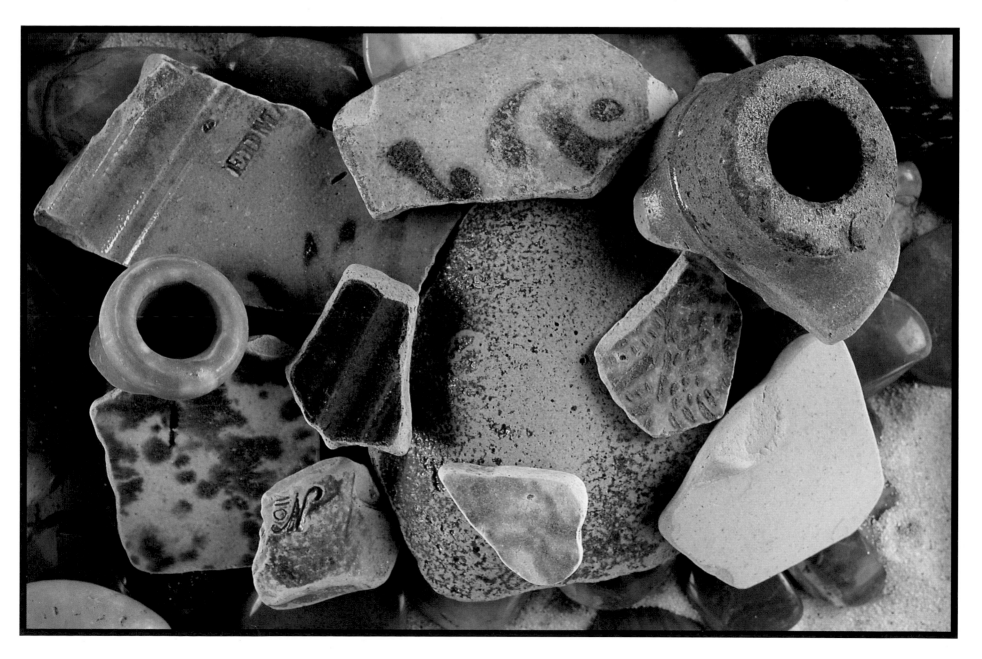

Sometimes the sea spins a peculiar kind of magic. Torn apart by waves, scraped by rocks, and smoothed down by the shifting sands, these fragments are given a new life. Having been refashioned by the forces of Nature, they roll onto the shore in identifiable shapes—in this case, hearts.

The largest shard in this grouping measures approximately 1¼" by 1¼".

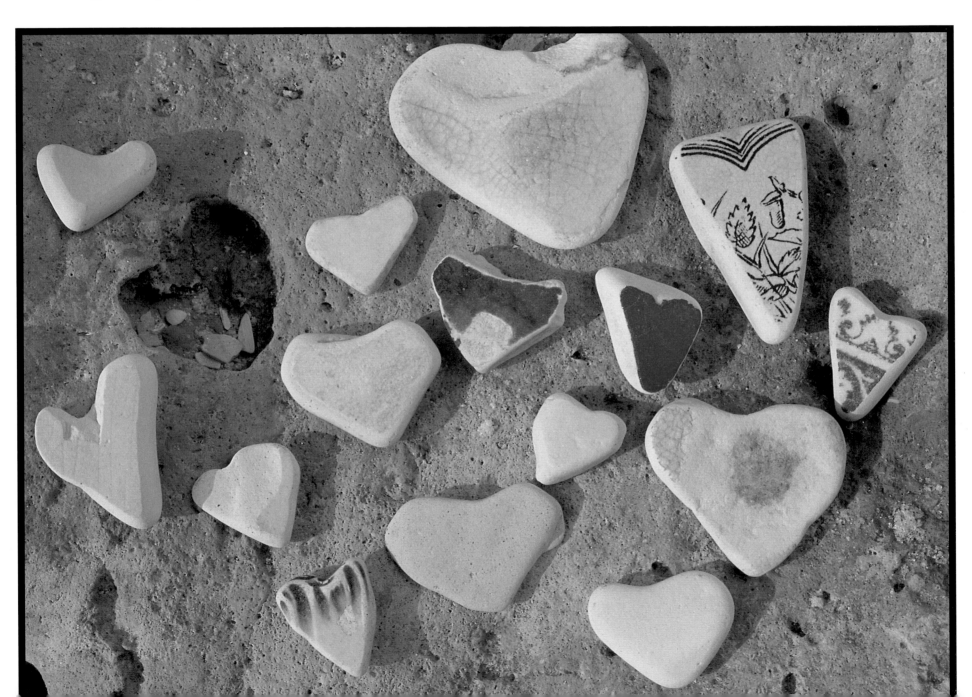

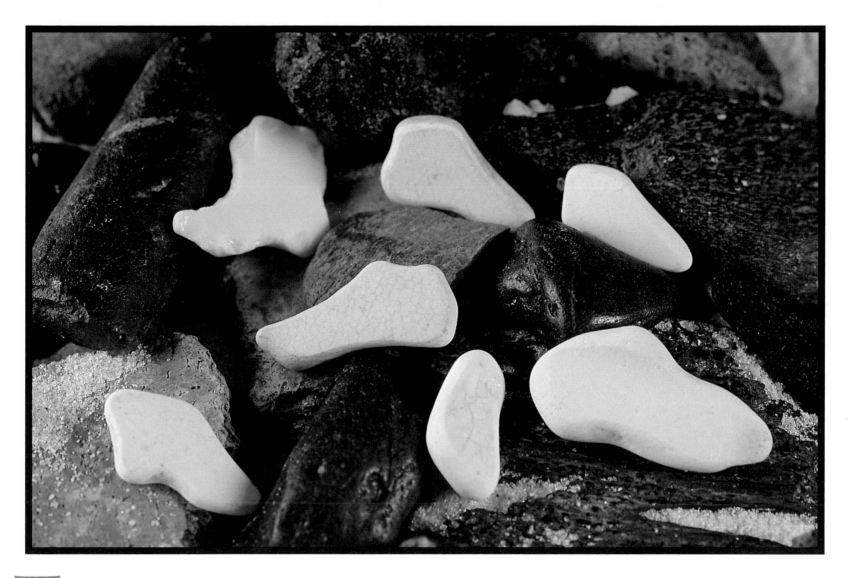

Three women—Nancy Sinatra, Imelda Marcos, and Ivana Trump— have surely brought more attention to footwear than numerous multimillion-dollar advertising campaigns for trendy athletic shoes.

The sea has naturally recast these earthenware shards into shoe and boot shapes. Perhaps this is Nature's salute to those who leave their footprints on our collective psyche.

The smallest of these shards measures about ¾" *by* ⅜".

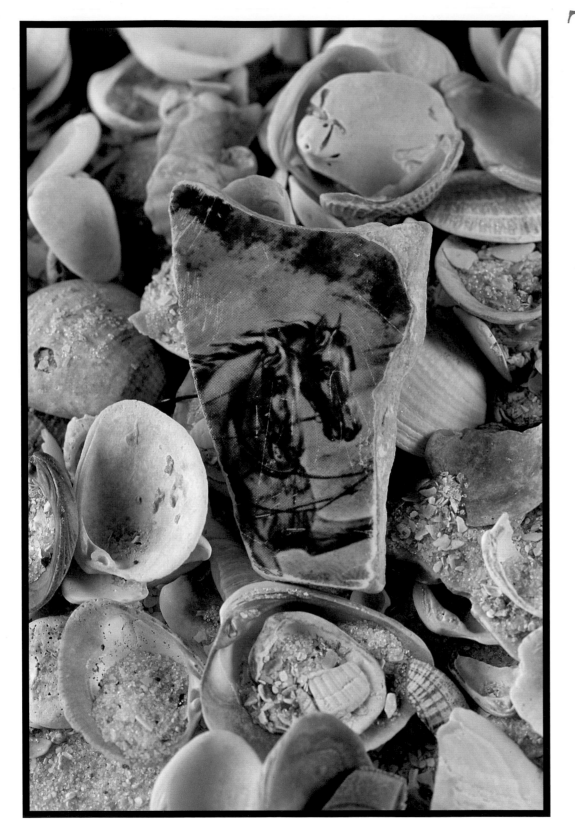

These two horses were undoubtedly taken from a Currier & Ives print. Known for recording historical events in addition to the social and economic life of nineteenth-century America, Nathaniel Currier and James Merritt Ives captured the spirit of the times with both romanticism and realism.

A letter sent to their sales representatives in the 1870s described "... nearly Eleven hundred subjects.... You will notice that the Catalogue comprises Juvenile, Domestic, Love Scenes, Kittens and Puppies, Ladies Heads, Catholic Religious, Patriotic, Landscapes, Vessels, Comic, School Rewards and Drawing Studies, Flowers and Fruits, Motto Cards, Horses, Family Registers, Memory Pieces and Miscellaneous in great variety, and all elegant and salable Pictures."

Hundreds of Currier & Ives prints reflected the public's keen interest in horses—for fashionable drives through city and country, as well as for competition at the racetrack. Celebrated champions of the day, such as the white-faced gelding named Dexter, were repeatedly honored in Currier & Ives prints. Aside from their professional interest, both Currier and Ives had a passion for horses and often accompanied their artists to the track while they made sketches.

This shard most likely originated as a commemorative earthenware edition of Currier & Ives prints. The artist was probably Thomas Worth, known for his cartoons and comics. His horse prints, however, are considered among his finest works.

It is easy to imagine that these two horses are, in the language of the late 1800s, "knocking the seconds down," or breaking an established record.

The shard measures approximately 2¼" by 1".

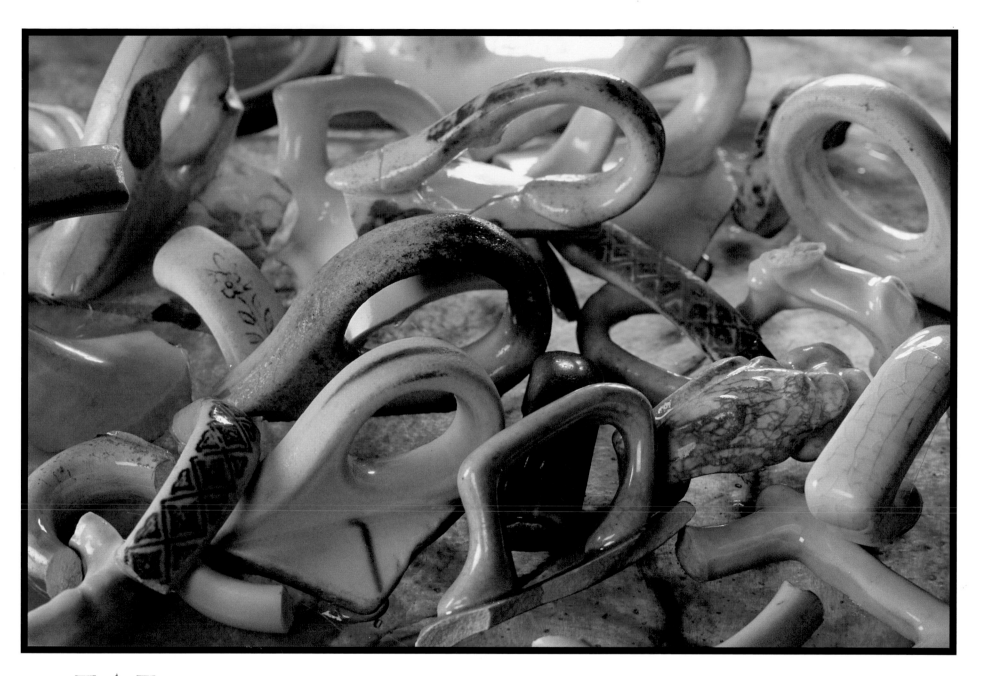

Whether imported from foreign lands or fashioned in America, these teacup handles connect us to a time three millenniums ago, when man first drank leaf-soaked water from cups with handles.

Some of these fragments can be linked to elegant Victorian afternoon teas with cakes, sandwiches, and cups of claret. Others tell tales of more rustic farmhouse meals, where—in the British vernacular—tea was so strong that a mouse could trot on it.

Still other handles remind us of the Chinese proverb, "The wisdom of ten thousand universes can be found in a cup of tea."

The average shard in this group measures approximately 1¾" in length.

These brown transferware shards represent a specific period in the history of decorative art. Known as the Aesthetic Movement, this design philosophy was born in the 1860s and espoused, "Art for art's sake." Simple beauty, craftsmanship, and Nature were key components. While Japanese art was perhaps the strongest influence in this style, crosscurrents from many cultures, such as Persian, Greek, and Italian, gave Aesthetic Movement transferware a quirky appeal.

English and American potters mimicked the art of the times in their brown transferware. In contrast to earlier ceramic patterns, where a border framed a scene, some Aesthetic-style transferware makers filled each piece with a single wallpaper-like pattern. Some floral designs were spare, while others were busy, as on a kimono. Perhaps the most striking patterns of the period displayed asymmetrical collages that bumped into each other.

Aesthetic Movement transfer printing resulted in earthenware that looked more like printed fabric than hand-painted china. Subdued brown colors made it highly popular for everyday use.

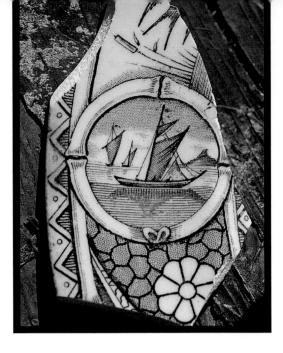

This fragment of "Phileau," a pattern by G.W. Turner and Sons of Tunstall, England, shows the asymmetrical-collage effect popularized by the Aesthetic Movement.

This shard measures approximately 1" by 2".

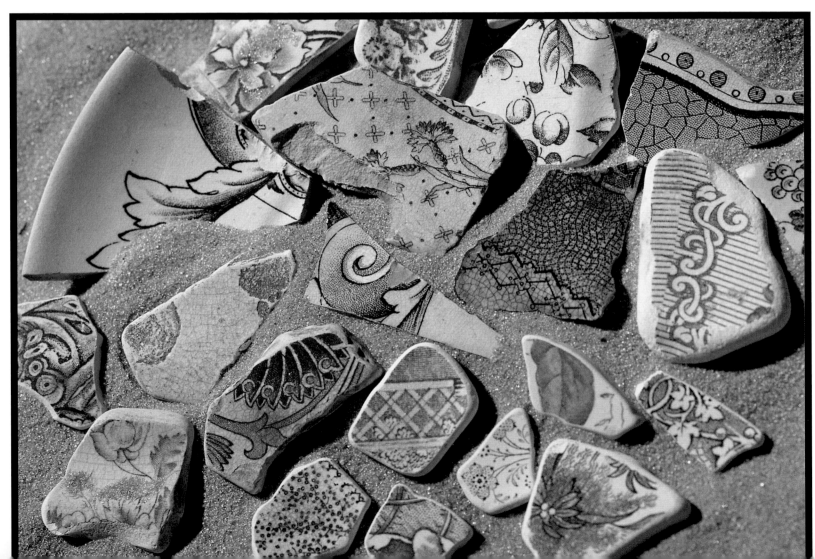

Scenes from fashionable "grand tours" of the Continent during the eighteenth and early nineteenth century began to appear on dinnerware around 1805. Drawings and watercolors from these tours were published in book form and were freely copied by engravers and potters. Both Europe and America, it would seem, had grown tired of the "chinoiseries" style that had predominated since the eighteenth century.

This fragment, from an "Italian Buildings" or "Italian Scenes" plate by Ralph Hall of Tunstall, England, shows the reluctance to completely break away from the Oriental motif. Here a Chinese junk sails past the Romanesque buildings in the background.

This shard measures approximately 1" by 1¾".

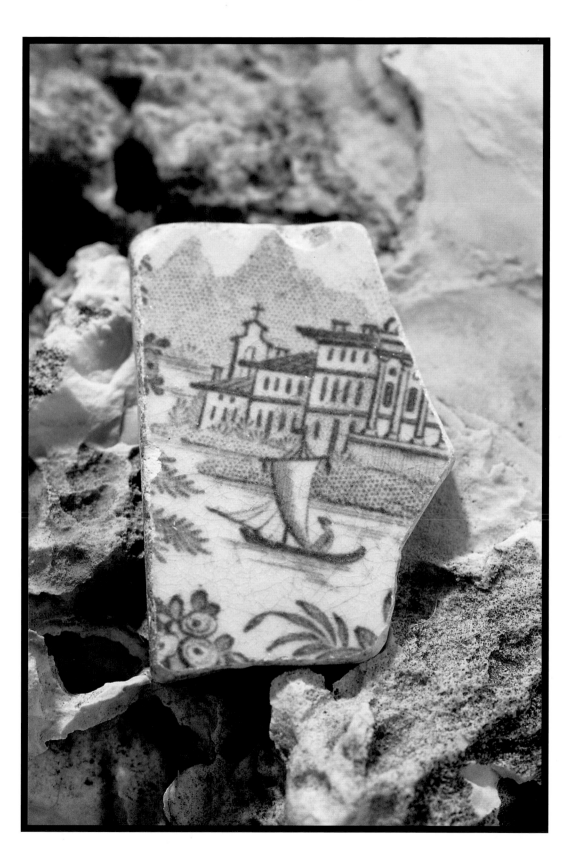

Following Commodore Matthew C. Perry's historic voyage to Japan in 1854 and the subsequent opening of trade routes, Japanese culture strongly influenced Western art—from architecture to fashion to ceramics.

America's 1876 Centennial Exhibition, which housed an exotic Japanese display, sparked a sort of Japan mania in Victorian America. Subsequently, William Gilbert and Arthur Sullivan triumphantly lampooned the craze in their light opera libretto, *The Mikado*.

This shard, probably a fragment from a jardiniere or an umbrella stand, was made in Japan in the 1870s for export.

This shard measures approximately 5¼" by 2½".

A rich design with a blurry softness distinguishes this ceramic style from others dominated by blue and white. Even the name of the dinnerware from which these ceramic fragments came, Flow Blue, seems to coincide with their rerouted destinies.

The process that creates Flow Blue was discovered in 1545 in Germany. Applied to a porous plate, cobalt oxide blurs naturally during the glazing process, resulting in a deep, rich blue design. Aside from its aesthetic qualities, the blurring was beneficial in covering defects such as bubbles in the glaze and flaws in the printing.

England's Wedgwood company further refined Flow Blue in the early 1800s. Adding a glaze of saltpeter, white lead, and borax spread the blue into the surrounding glaze, creating a halo effect.

The largest shard in the group measures approximately 4 ¼" by 1¾".

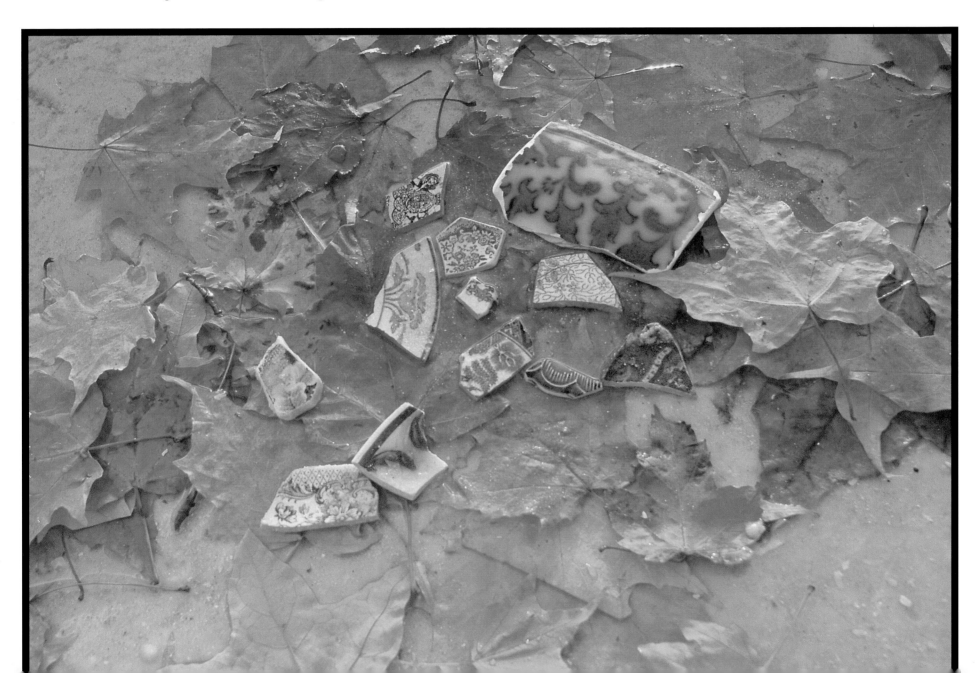

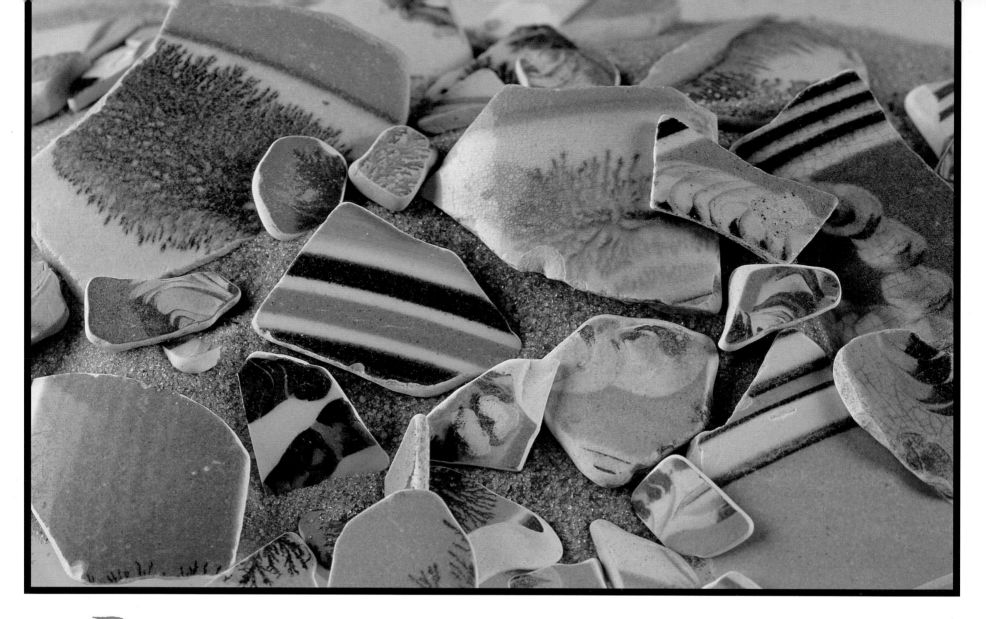

Psychedelic swirls, seaweed patterns, modernistic lines, and bright blue and pumpkin colors—these characteristics might fool the untutored eye as to the age and purpose of this unassuming pottery. Known as mocha ware, it was created during the late 1700s and was considered bottom-of-the line earthenware. Mocha ware was designed for service in kitchens and pubs, and it was not intended for table service or decorative use.

The lacy seaweed pattern, which experts describe as the only true mocha decoration, was created by coating an unfired piece with a mixture that included a curious combination of tobacco juice, hops, stale wine, and urine. The chemical reaction resulted in a design resembling the popular mocha stone jewelry that was worn at the time. Hence the origin of the pottery's name.

Mocha ware came to America primarily from Leeds and Staffordshire, both in England. Ironically, a whole, undamaged piece of this once inexpensive, commonplace pottery can fetch several thousand dollars on the antique market.

The largest shard in this grouping measures approximately 2½" by 1⅞".

This fragment sets the standard by which the finest ceramic shards could be measured. The pottery's pictorial design has not been diminished, even though the glaze has been buffed away by the sand and sea. Though broken off from the rest of the scene, the pattern clearly reveals a story.

Here stand two ladies in flowing dresses, topped with bonnets, and wrapped in shawls. Next to them, a curved stone bench connects to a balustrade leading downward. A darkened area below probably denotes a tree's shadow or possibly a body of water. The second woman on the shard is looking to her right, just where the fragment ends.

The relative positions of these elements indicate that this is the lower left portion of the design theme. And by the shard's dimensions, we know that it is less than one-fourth of the original picture. These clues help identify the piece as part of a "Lozere" plate by E. Challinor, an English potter. This type of transferware dates from 1842 to 1867.

This shard measures approximately 1⅓" by 1¼".

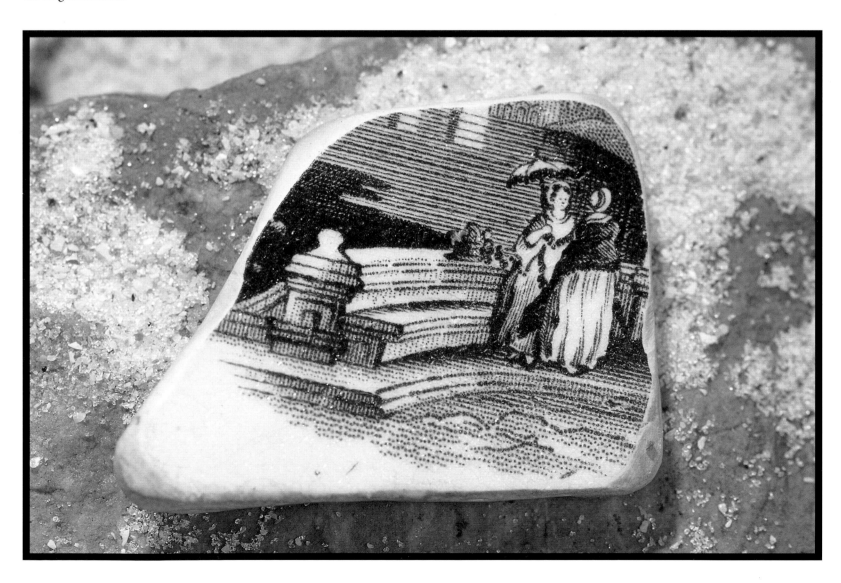

Avocational beachcombers tend to make associations with sea glass. Sometimes they are symbolic and sometimes prophetic. Here, a white fragment bears one of the first backstamps used by Buffalo China, circa 1915. The name Lambert most likely belongs to the artist who hand-painted the piece.

That moniker is shared by the author, who found this shard.

This shard measures approximately 2" by 1¾".

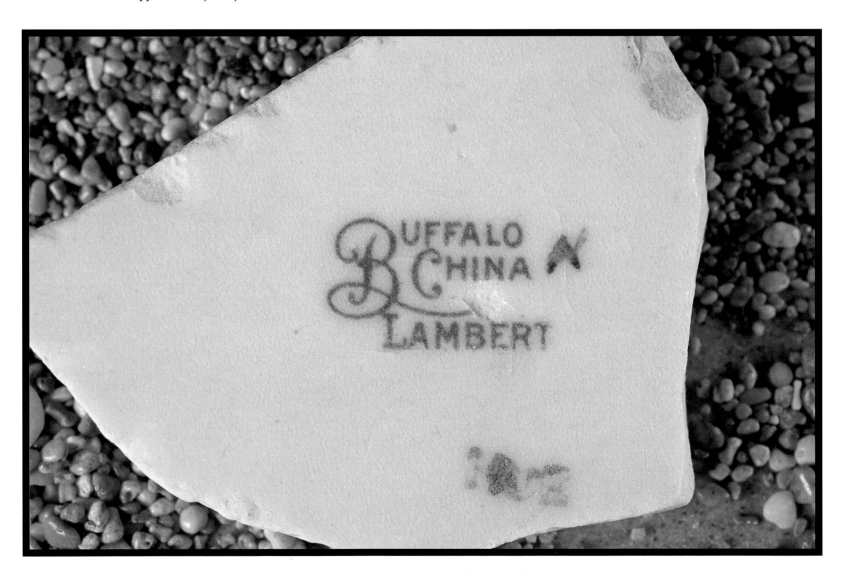

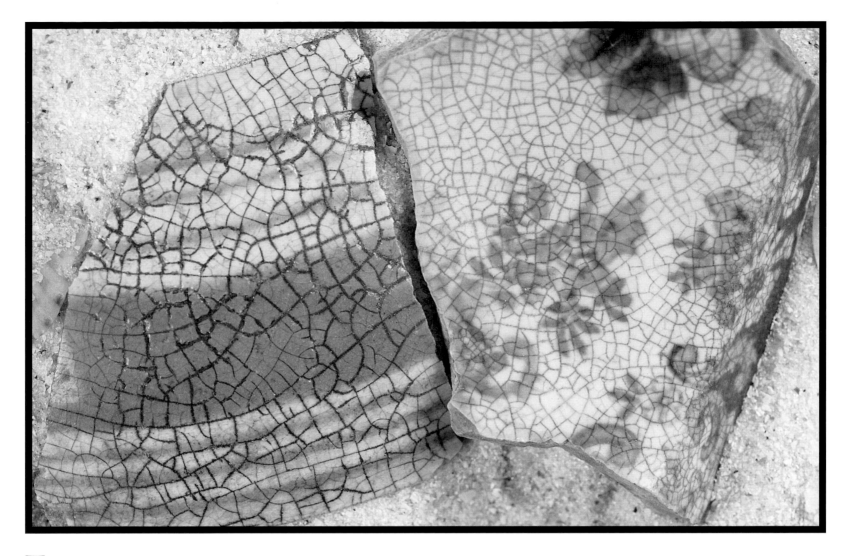

L ike maps, these shards contain an intricate network of intersecting lines. Years of endless changes in both air and water temperatures caused the ceramic body and the surface glaze of each piece to expand and contract at different rates. The cracking that results from such mis-timed, unequal shrinkage is known as crazing.

The original pieces from which these shards came were probably made before 1885. By that year, potters had refined the glazing process, making their wares more resistant to crazing.

The smallest shard measures approximately 1¾" by 1".

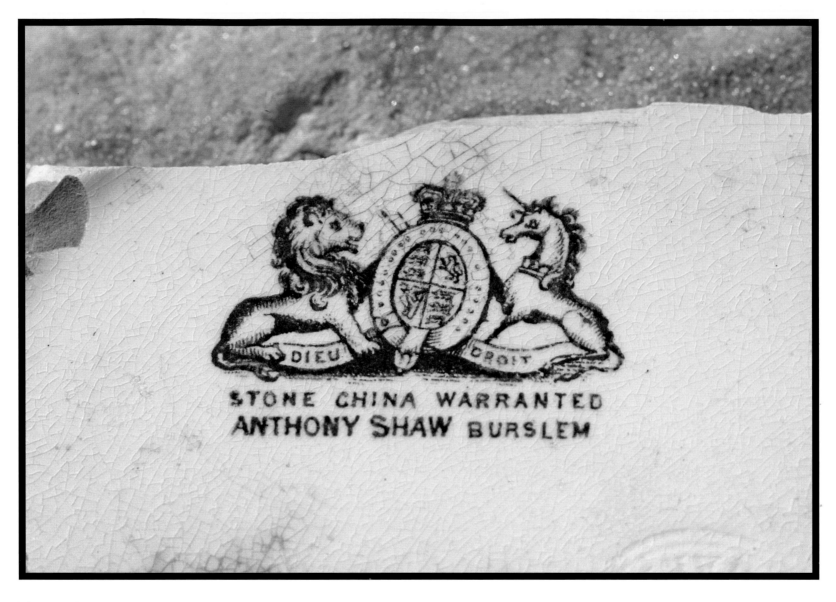

STONE CHINA WARRANTED
ANTHONY SHAW BURSLEM

Much of the history of the British royal family is symbolized in this ceramic shard, which is imprinted with the Royal Coat of Arms. In this case the design is a "backstamp" on the flip side of a piece of pottery.

The lion represents England, while the unicorn stands for Scotland. In the center of the design, a large shield holds four smaller ones. The first and fourth quarters embody the Plantagenet lions of England. The second quarter contains a Scottish lion rampant, or standing, while the third quarter holds the Irish harp, which symbolizes Northern Ireland.

"*Honi soit qui mal y pense*" encircles the shield. These words can be traced to an English celebration following the capture of Calais, France. There the Countess of Salisbury lost her garter; King Edward III reputedly retrieved it, slipped it over his own knee, and responded to pundits, "shamed be he who thinks evil of it."

In 1348, the king and twenty-six of his knights and leading peers established the Order of the Garter and devoted their lives to chivalrous acts. This phrase still stands as their royal slogan.

The banner at the bottom of the heraldic shield, "*Dieu et mon droit*," means "God and my right."

This shard measures approximately 2¼" by 1¾".

These fractured remnants from early
marmalade pots offer a glimpse into
the history of some prized oranges.
Late in the eighteenth century, according to
legend, a storm-driven Spanish galleon sought
shelter in Scotland's Dundee harbor.

A local grocer, James Keiller, bought the
ship's cargo of Seville oranges and turned
them over to his wife. Noting the fruit's bitter
taste, she boiled the rinds and pulp in sugar.
The resulting flavor differed from anything
the grocer's regular patrons knew, and Mrs.
Keiller's invention was an immediate success
in the family store. She called the new product
"orange marmalade."

In 1797, the family established James
Keiller & Son—the world's first marmalade
firm and the makers of Dundee Marmalade.
Probably dating from the mid-1800s, these
shards reveal another twist in the destiny of
the famed oranges. An English merchant
trader loaded with marmalade foundered off
the rocky New England coast and disgorged its
contents, giving American sea creatures a taste
of the condiment made in Scotland from
Spanish oranges.

*The largest shard in this group measures 3" by
2³⁄₈".*

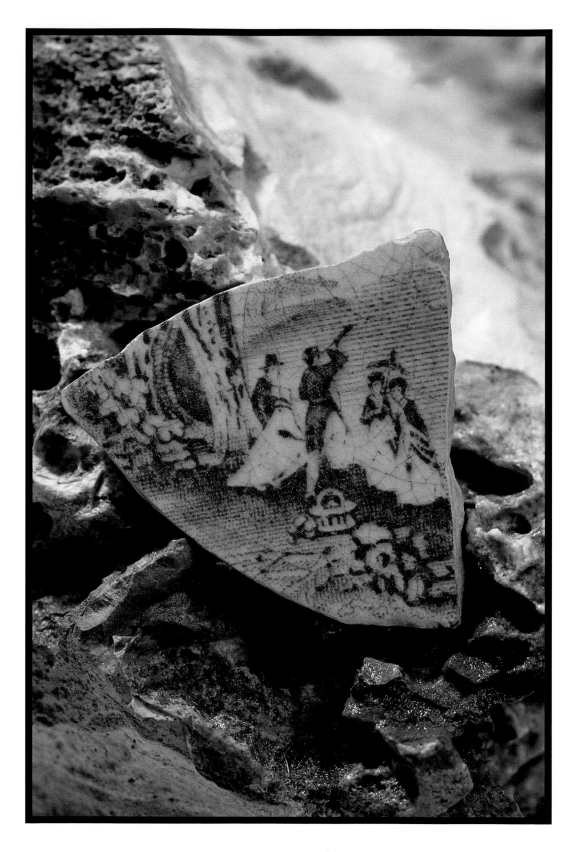

Prominent figures were often honored on earthenware. This partial scene comes from a plate that was made in Staffordshire, England. It belongs to a pattern named after the Swedish opera singer Jenny Lind.

Also known as the Swedish Nightingale, Lind sang without peer in opera houses and theaters throughout Europe and the United States during the mid-nineteenth century. A sort of Jenny-Lind craze ensued.

Discovered at the age of nine and admitted the next year, 1830, to the Royal Theater school of voice in Stockholm, she went on to study with the celebrated Manuel Garcia in Paris. Lind sang at the coronation of Sweden's King Oscar and performed for England's Queen Victoria and Prince Albert. Later in her career, Lind toured the United States under the management of P.T. Barnum.

This shard measures approximately 1½" by 1¾".

If dishes could talk they might tell us about a world where families live in shoes, and geese lay golden eggs. These shards belong to the ceramic genre known as ABC pottery, or children's ware. Created both to entertain and to enlighten, the dishes displayed moral edicts, messages of endearment, or simply a child's name. Some featured nursery rhymes.

ABC dishes were especially popular during the Victorian era. Then, children learned social graces by emulating adult table behavior, and they commonly practiced by hosting tea parties with their dolls and stuffed animals.

The largest shard in this group measures approximately 1¼" by 2¼".

Lost for centuries, these relics from the Ming dynasty (1368–1644) washed up on Thailand's Chao Phraya riverbanks in the 1990s. Chinese trading vessels laden with porcelain, among other goods from the Orient, regularly sailed these waters en route to the ancient Thai capital Ayuthaya.

The thick glaze that characterized Ming period wares probably helped to protect the distinctive cobalt-and-white patterns from fading. Inspired by silk brocades of the same era, the hand-painted floral designs echo the superior standard of materials and decoration used at the time.

Similar fragments, retrieved off Fortune Island in the Philippines, have been linked to the doomed *San Diego*. This Spanish galleon, which traveled the profitable trade route between Manila and Acapulco, sank nearly four hundred years ago. More Ming-dynasty shards, the result of the shipwrecked Spanish galleon *Nuestra Señora de la Concepción* in 1638, have been found along the shores of the western Pacific island Saipan.

The larger shard measures approximately 1⅛" by 1¾".

Created almost two hundred years ago, Blue Willow remains the most popular pattern to appear in the history of dinnerware. Nearly a hundred and fifty potters from thirteen countries made variations on the same theme. Juxtaposed on an unbroken plate, these fragments illustrate just a sampling. Brown, red, and green printings in the Willow pattern were introduced but never achieved popularity.

The design conveys a Chinese legend: Hong Shee, the daughter of a wealthy mandarin, fell in love with Chang, one of her father's employees. Hong Shee's father forbade the match and imprisoned his daughter in the family palace. But Hong Shee escaped and joined Chang, who had a boat waiting in the harbor.

During their journey to independence, a storm developed. Tragically, the boat capsized, and the couple drowned. According to the tale, two lovebirds, representing the spirits of Hong Shee and Chang, subsequently soared above the wreck.

The smallest shard in this grouping measures approximately ½" by ½".

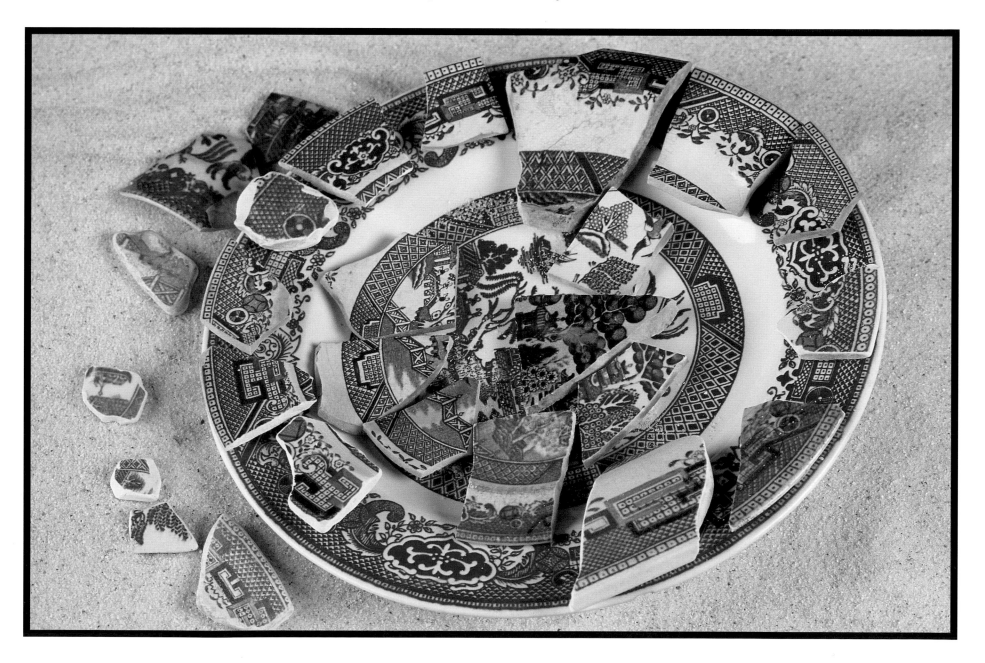

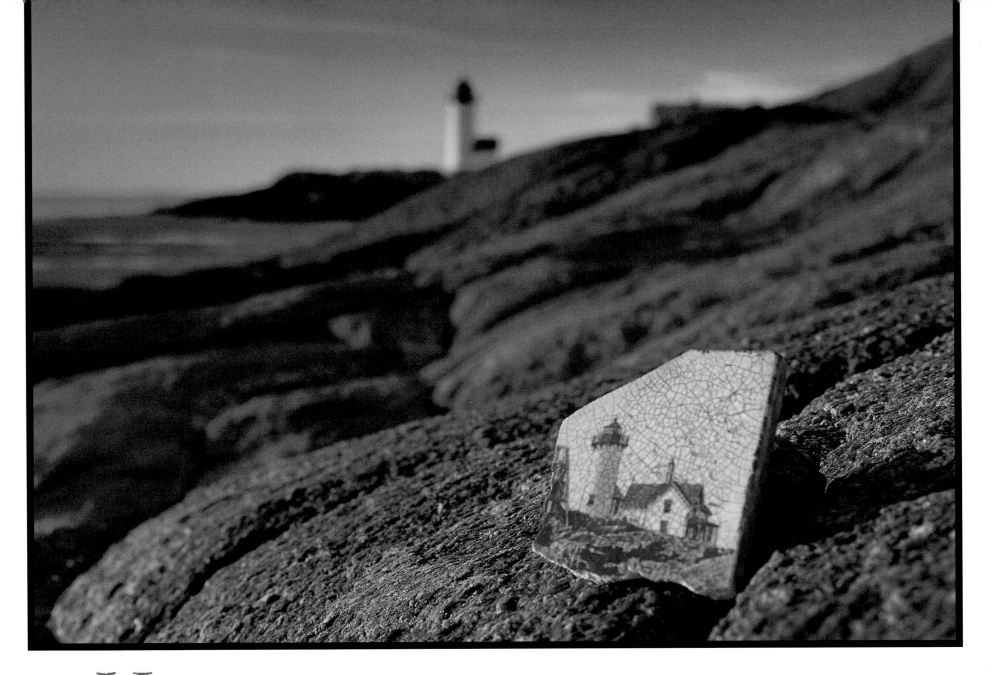

Here is allegory gone awry. Battered by a rugged coastline and found in a rocky inner harbor, this wrecked lighthouse scene washed ashore in the wake of a storm. The ill-fated shard met the end that the subject of its illustration protects against.

The wavy back of the fragment and its thickness suggest that it is part of a hot-plate tile or a fireplace surround.

This shard measures approximately 2¾" by 3".

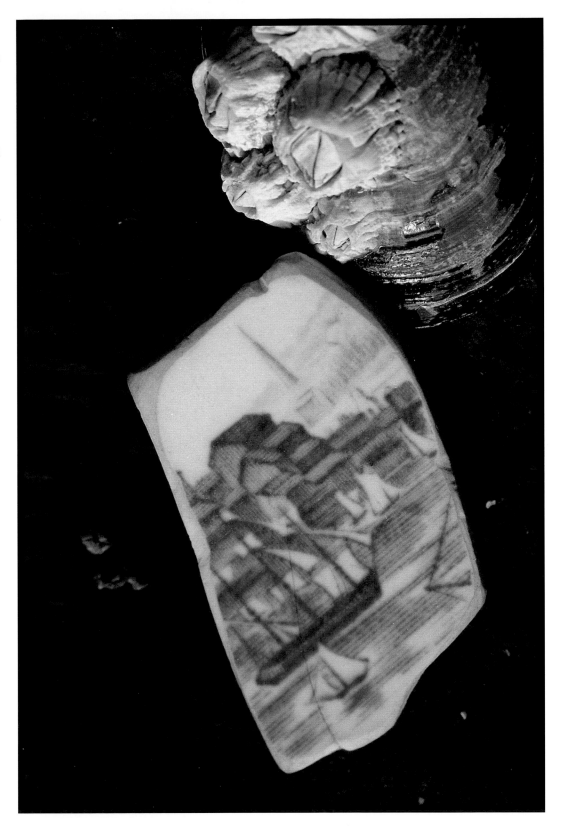

Would the British government find poetic justice in the circumstances surrounding this shard? Found in a Massachusetts harbor not far from the site of the Boston Tea Party, the fragment belongs to a pattern called "View from Boston Harbor."

Johnson Brothers pottery in England's Staffordshire district produced this historical design between 1800 and 1900. A blue-printed transferware pattern, it was created specifically for the American market.

This shard measures approximately ¾″ by 1¼″.

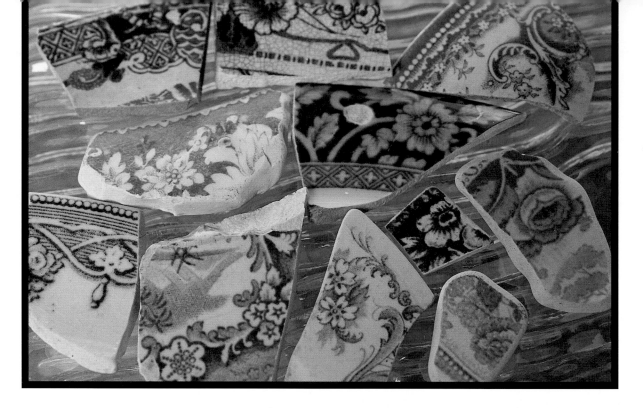

Wallpaper patterns inspired the swirling lines and interlocking geometrics of the floral, foliate, and fruit motifs seen on these ceramic fragments. Reminders of the lavish pre-Victorian era, these richly colored shards echo a time when dinner guests were escorted from the drawing room and into the dining room in order of rank.

The English engraver William Brookes first incorporated contemporary wallpaper patterns into blue-printed wares. He used various patterns as borders in order to frame each design in the center of the earthenware. Although colors other than blue gained popularity, wallpaper-inspired borders continued to be a prominent feature of transferware.

The largest shard in this group measures approximately 1¾" by 2".

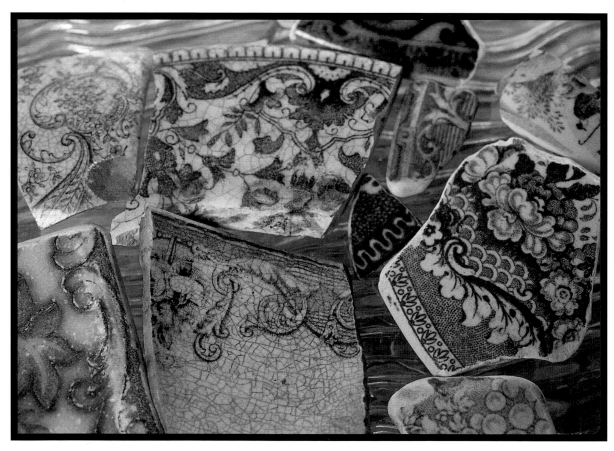

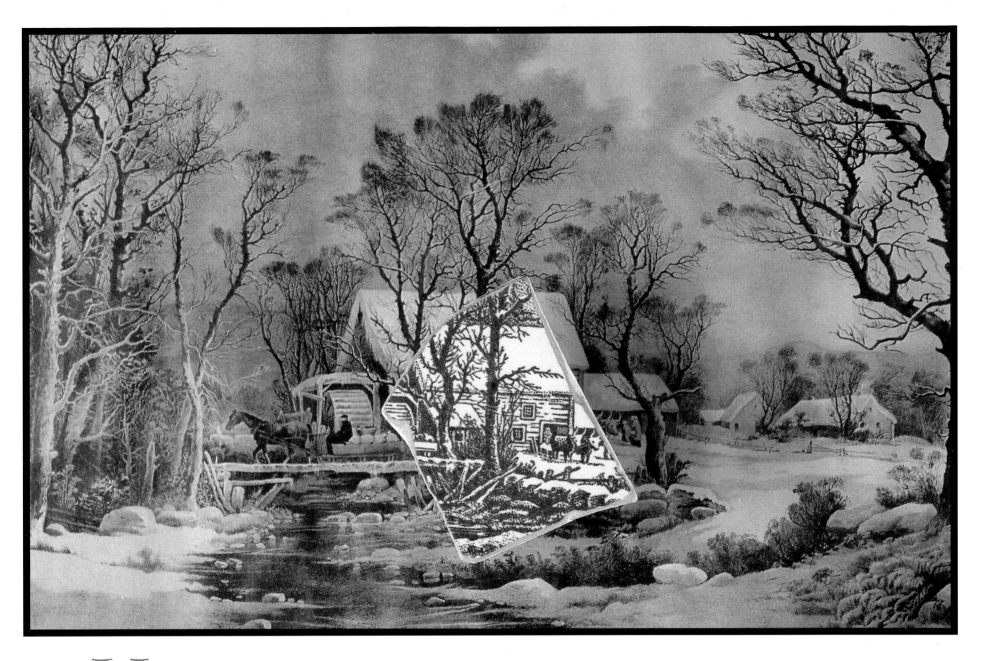

Unfortunately the soft, subtle colors of a snowy late afternoon in New England are lost on this cold blue-and-white earthenware. Notwithstanding its starkness, the design on this shard is faithful to a Currier & Ives print, "Winter in the Country, The Old Grist Mill," which appears in the background of the photograph.

The print was made in 1864 from an original painting by George Henry Durrie. Most of this artist's paintings were inspired by the Connecticut region, and most of his subject matter was within walking distance of his North Haven studio.

A staunchly religious man, Durrie would never enter the studio on Sundays for fear that he would be tempted to paint. He focused on quiet rural beauty, and his work featured accurate details of Nature. Because of the artist's preference for snowy New England scenes, Durrie was known as "the snowman."

While Currier & Ives reproduced only twelve of Durrie's paintings, he remains a favorite among Currier & Ives enthusiasts. In the 1940s, the Royal China Company of Sebring, Ohio, created this ceramic pattern. It was a popular store premium, or giveaway, and is still being made.

This shard measures approximately 1½" by 2".

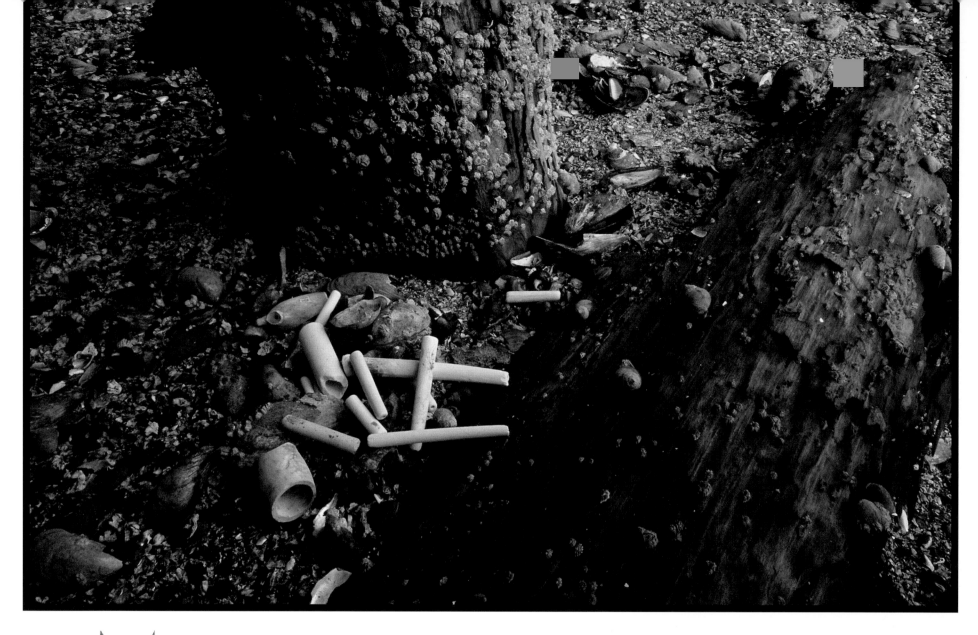

Made in large numbers from the 1500s to the 1800s, clay pipes—or fragments of them—wash ashore regularly. Some of the mystery behind these pipe stems and bowls can be solved. At least one still bears the partial imprint of its origin: Glasgow, Scotland.

Between the late 1500s, when pipe making was introduced in Europe, and the late 1700s, pipe stems grew longer and thinner. As a result, stem holes became proportionately smaller. One widely accepted method of dating clay pipes calls for simply measuring the diameter of these apertures. For example, in the period between the early seventeenth century and the late eighteenth century, stem holes decreased in size from 9/64" to 4/64".

Many of these stems date between 1680 and 1710.

The average shard in this group measures ¾" long.

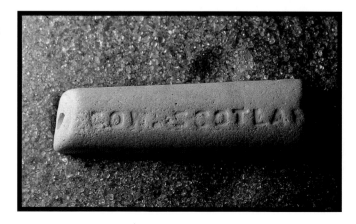

Nineteen forties and fifties nostalgia jumps right out of these dinnerware fragments. Orangy red, pale green, sunshine yellow, orange, and rose capture the retro style so aptly translated in the Fiesta ware pattern, created by the Homer Laughlin China Company.

The red pieces are the rarest because they were the most expensive to make. When the U.S. government took control of uranium oxide (a key ingredient in red Fiesta ware) during wartime in 1943, Homer Laughlin dropped the color from its series.

When red was brought back into the marketplace in 1959, rumors abounded that the colored glaze was radioactive. Incredibly this false information still persists today.

The largest shard in this grouping measures approximately 2½" by 2".

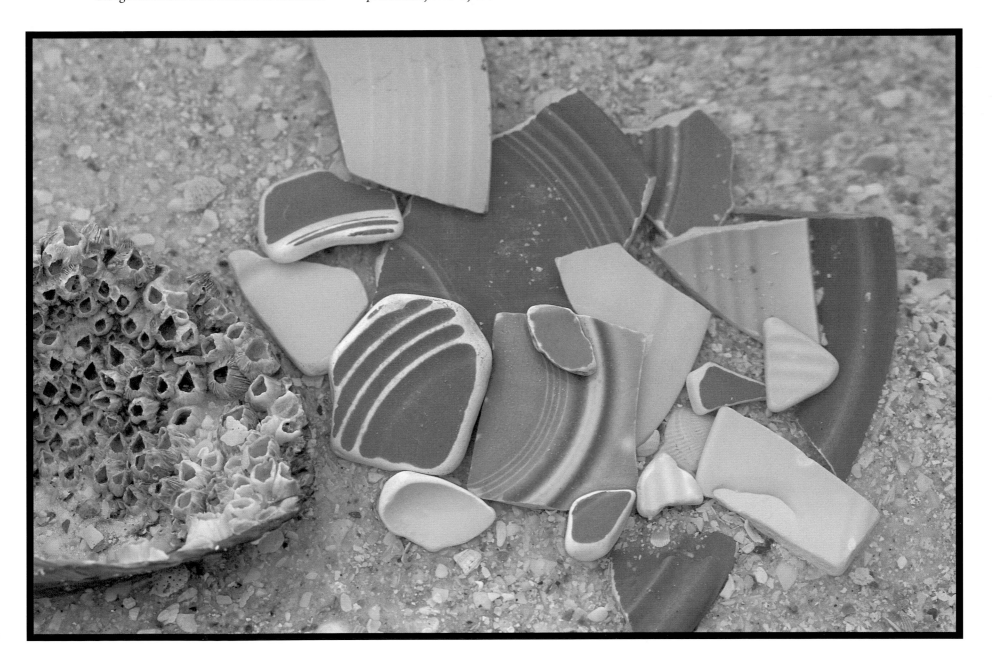

Art imitates life as fragments of earthenware mingle with the inspiration of their design—seashells. Much as shells are the remains of underwater species that have died or outgrown their armor, these ceramic pieces are also survivors of another life.

The catalogs of two English firms, Enoch Wood and Herculaneum Pottery, listed shell-border patterns in the early nineteenth century.

The largest fragment measures 1¼" by 1⅜".

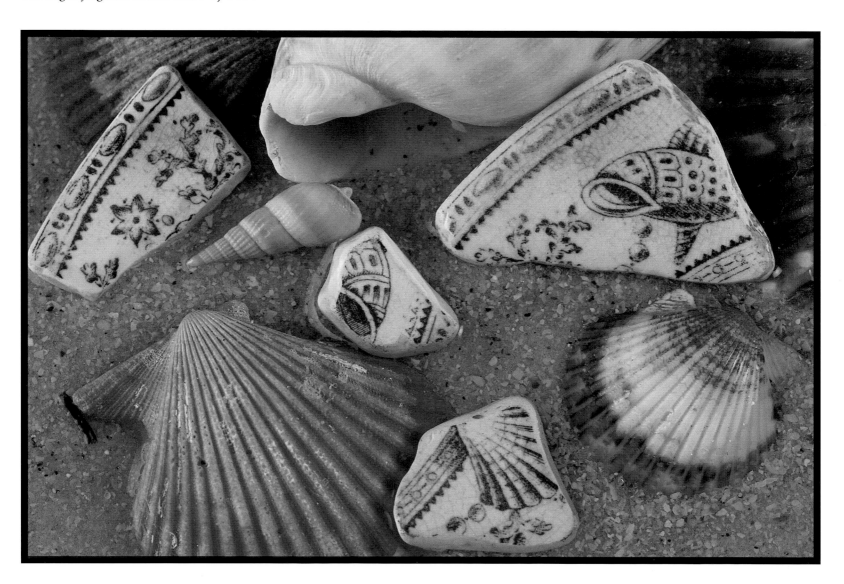

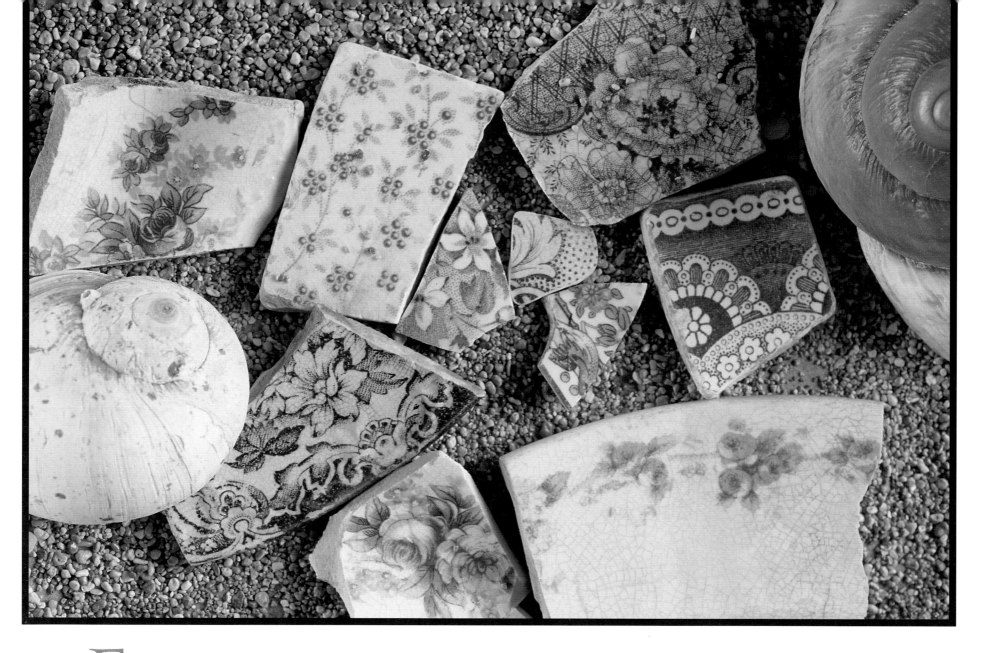

Floral blossoms and fruit berries show up on many beaches in the form of chintz-patterned shards of pottery. Inspired by cotton-fabric designs exported from India, seventeenth-century English potters created colorful floral patterns in a seemingly infinite number of variations. The founder of Royal Winton took his chintz patterns directly from aprons worn by the women who worked in his factory.

The multitude of these charming, colorful patterns—and the resulting volume of shards on our beaches—owe to the development of transfer printing. Previously hand-painted, chintzware could now be mass-produced. The style came into everyday usage both in Europe and abroad.

Chintz china has come in and out of fashion over the centuries, but the style has become synonymous with afternoon tea in England.

The largest shard in the group measures approximately 2" by 1".

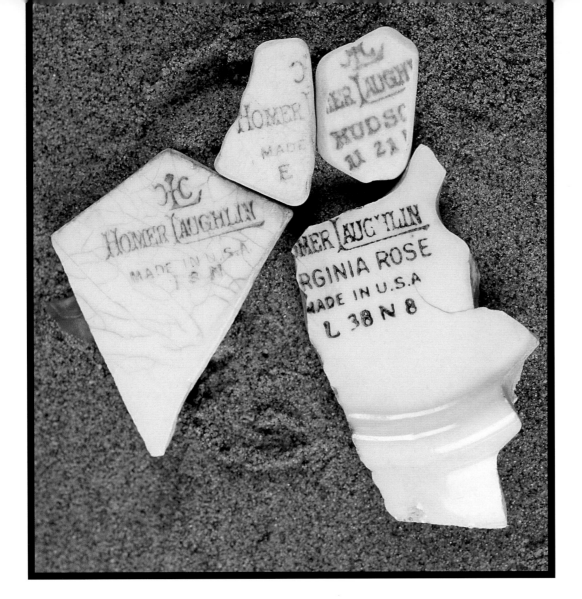

Perhaps the most recognizable shards on American beaches bear the insignia of the Homer Laughlin Company. The volume of these fragments owes to the fact that this firm leads the United States in china manufacturing. A distinctive back-stamp makes them easy to identify. The central group of shards here can be dated from 1900 to today.

Two Laughlin brothers with literary names, Homer and Shakespeare, opened their two-kiln pottery factory in East Liverpool, Ohio, in 1871. Over the years, the family business grew into a ceramics empire, with plants in and around Liverpool and in Newell, Virginia. Their wares were widely distributed through Woolworth's, Wards, and Sears, and they became popular as premiums.

One of the shards shows part of the name "Virginia Rose." Unlike most such markings, "Virginia Rose" is the name of a shape, not a decoration. This pottery is often adorned with a decal designated "Wild Rose." The numbers at the bottom of the shard tell that it was made in December (L) of 1938 (38) at plant number 4 (N) in August (8). "Virginia Rose" lists among the most popular shapes created by Homer Laughlin.

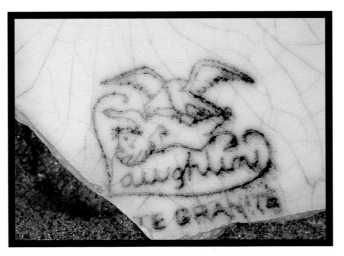

This trademark was employed between 1877 and 1900 as a symbolic statement: America, represented by the eagle, was no longer dominated by England, the lion, in china production.

This shard measures approximately 2" by 2¾".

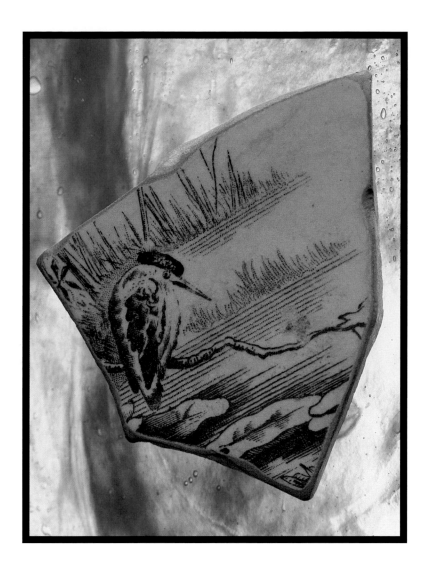

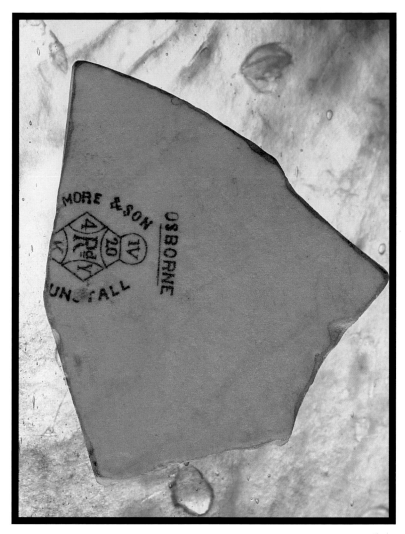

The black-crowned night heron on this shard rests on a crooked branch, his head feathers reminiscent of one of Jackie Kennedy's pillbox hats. The bird seems to stare at its onlookers from every angle, in the manner of Rembrandt's portraits with their "following eyes."

The flip side of the shard identifies the pattern name: "Osborne." The diamond-shaped icon reveals that this plate or platter was made on November 20, 1879. The "Rd" means that the pattern is registered, and the encircling letters identify this as a product of T. Elsmore and Son of Tunstall, England.

This shard measures approximately 1¼" by 1¾".

It is not difficult to imagine author Charles Lamb (1775–1834) at his normal Wednesday evening open house in London, with William Wordsworth and William Hazlitt among the literati in attendance. Lamb nicely described a teacup in his essay "Old China":

"Here is a young and courtly Mandarin, handing tea to a lady from a salver—two miles off. See how distance seems to set off respect! And here the same lady, or another—for likeness is identity on teacups—is stepping into a little fairy boat, moored on the hither side of this calm garden river, with a dainty mincing foot, which in a right angle of incidence (as angles go in our world) must infallibly land her in the midst of a flowery mead—a furlong off on the other side of the same strange stream!

"Farther on—if far or near can be predicated of their world—see horses, trees, pagodas, dancing in the hays."

This shard measures approximately 1" by 1⅛".

One artist, William Gilpin, provided inspiration for many of the potters, in Staffordshire, and this image might have been copied from his illustrations. A clergyman by profession, Gilpin traveled across England at the turn of the nineteenth century and painted scenic and city views. His distinctly romanticized interpretations, published as aquatints, drew many imitators. The influx of such fanciful drawings and paintings became known as the "cult of the picturesque."

The image on this shard is a tiny part of a large coastal village scene, and the woman in a dust cap is actually a fish peddler. An unknown Staffordshire potter created this flow blue pattern, "Fisherman's Hut," in the mid-1800s.

This shard measures approximately 1⅛" by ⅜".

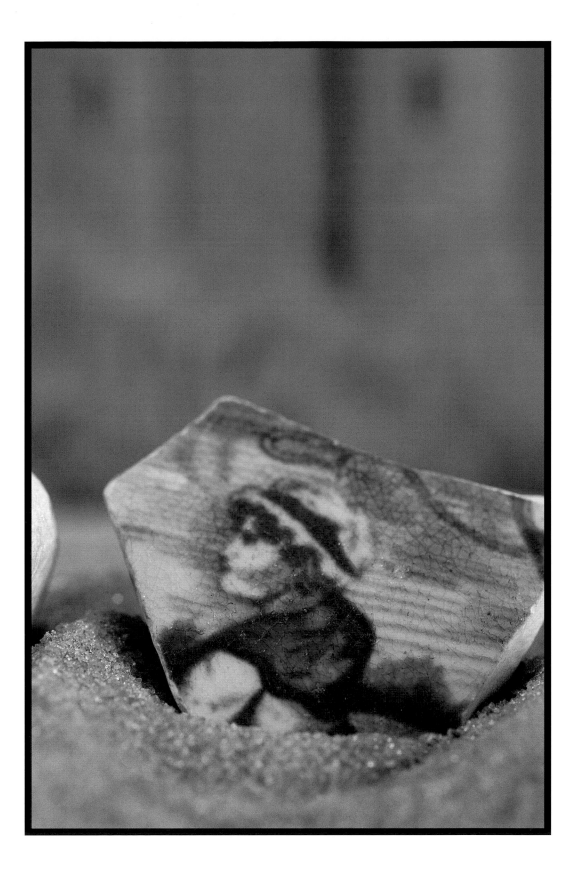

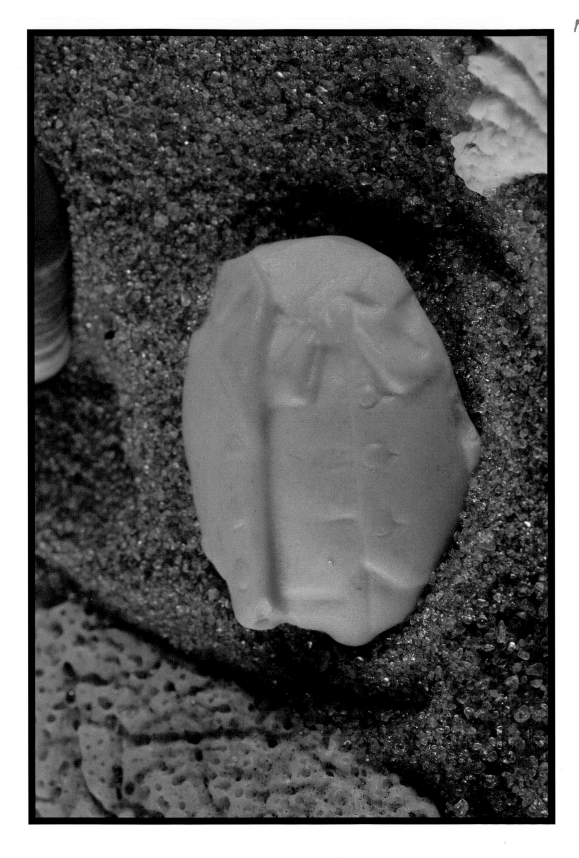

The unmistakable paunch behind the button-strained vest, floppy tie, and high-collared jacket suggests that this earthenware shard is part of a Toby Jug. Sand and sea probably abraded away its original enamel overglaze of dark browns, greens, and other earth tones.

The pattern emerged around 1770, when English potters created a series of jugs in the likeness of Toby Fillpot, a portly, jovial fellow known for his love of ale. Some historians like to point to Sir Toby Belch in Shakespeare's *Twelfth Night* as the inspiration for the anthropomorphic pottery, but others prefer to name Lawrence Sterne's creation, Uncle Toby in *The Life and Opinions of Tristram Shandy.* One likely clue to Mr. Fillpot's identity appears in a print published in the 1760s. It depicts a pot-bellied, smiling character seated in a garden, holding a pipe in one hand and a mug of ale in the other. The print also includes a set of verses entitled "Toby Fillpot."

A number of versions of the Toby Jug have been produced since the eighteenth century. The name Toby, a diminutive of Tobias, has become playfully synonymous with a plump, jovial drunkard and a drinking mug. As the character Gabriel Varden philosophizes in Charles Dickens's *Barnaby Rudge,* "Ah, well, it's a poor heart that never rejoices. Put the Toby this way, my dear."

This shard measures approximately ⅞" by 1¼".

O f English or American origin, this glazed fragment dates from around 1880. Created for everyday use, Rockingham pottery was common yellow ware with a brown manganese glaze. The imposing raised Mandarin figure was central to the decorative theme on a batter pitcher or jug.

This shard measures approximately 2" by 3¼".

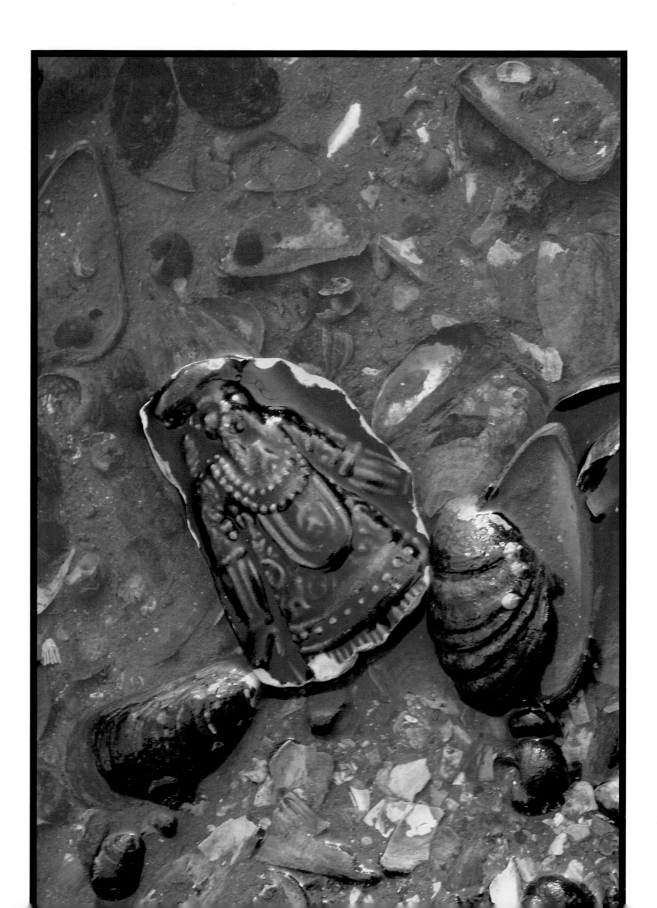

III Frozen Charlottes and Other Personae: Ceramic Doll Parts

Looking for sea glass can be viewed as a sort of Rorschach test. That is, we see what the unconscious mind dictates. And our search is often complicated by blinding sun reflecting off the water's edge and refracting from grains of sand.

The least-known examples of sea glass—tiny ceramic doll and figurine body parts—look remarkably like shells. In most cases, their hand-painted exteriors have long since been worn down, revealing a chalky matte finish. Though they're harder to spot, these body parts are surprisingly more common than ceramic tableware shards with transferware scenery.

Most of the pieces in this section originated in mid-nineteenth-century German and French doll factories. The volume and variety found on certain beaches suggest that merchant ships carrying trunk loads of this precious cargo, among other treasures, were wrecked or scuttled nearby.

The fragments in the following pages came from dolls and figurines of varying sizes. It is worth noting that among the hundreds of ceramic body parts examined for this collection, no two arms, legs, ears, heads, or bodies matched.

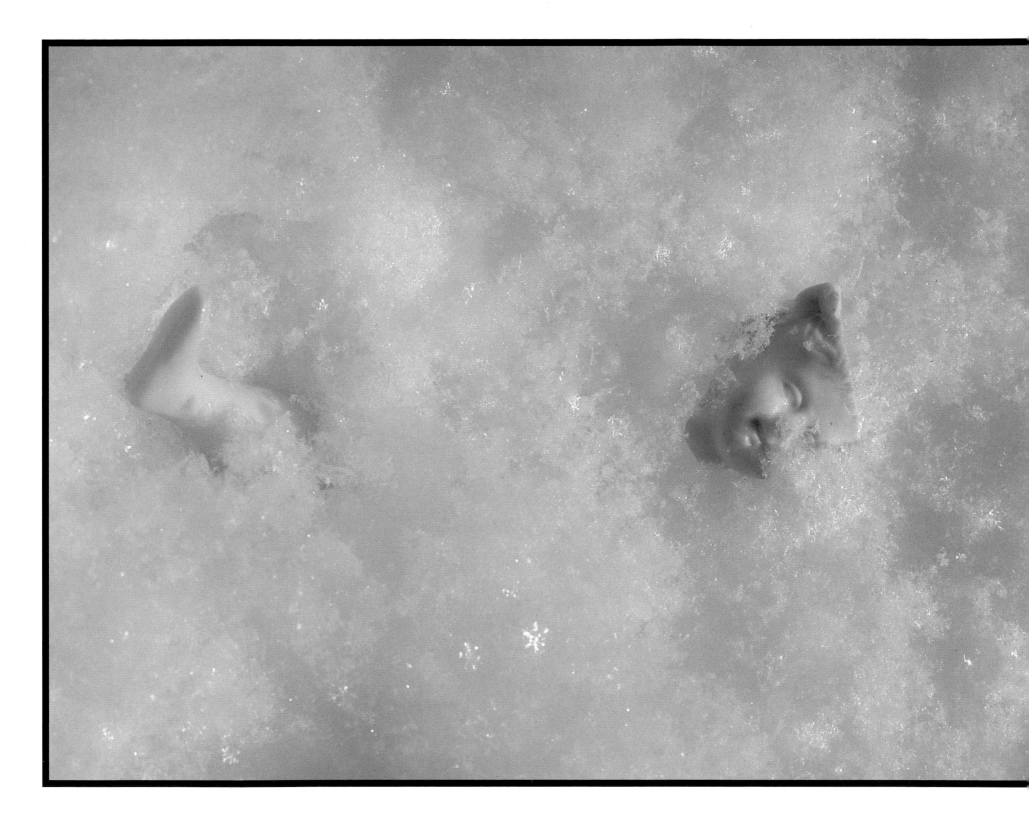

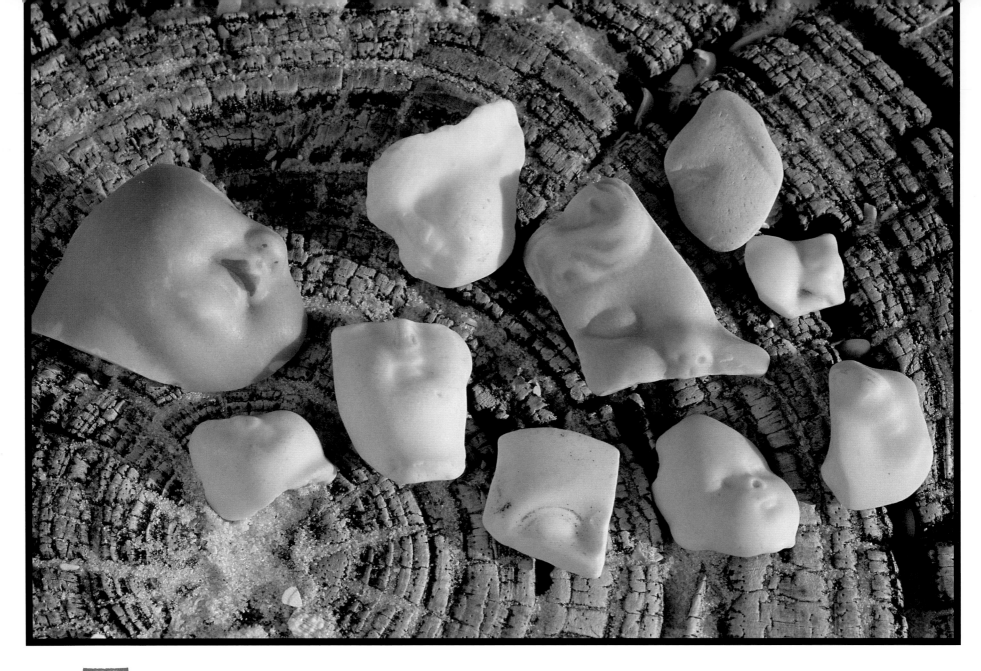

These ten fragmented faces probably span three centuries of doll and figurine manufacture in England, France, Germany, Japan, and America. Their hand-painted features—pale blue or brown eyes, whispy eyebrows, and tiny red nostrils and mouths—disappeared long ago. Only one face survived with its colored surface intact.

The largest shard in this group measures approximately 1½" by 1¾".

T angled in seaweed, this remarkable arm
seems to beckon passersby. Shadows
cast by the winter sun on a blustery
February day highlight the creases in the palm
and bent fingers, giving the hand an eerie,
lifelike quality.

This shard is approximately 3" long.

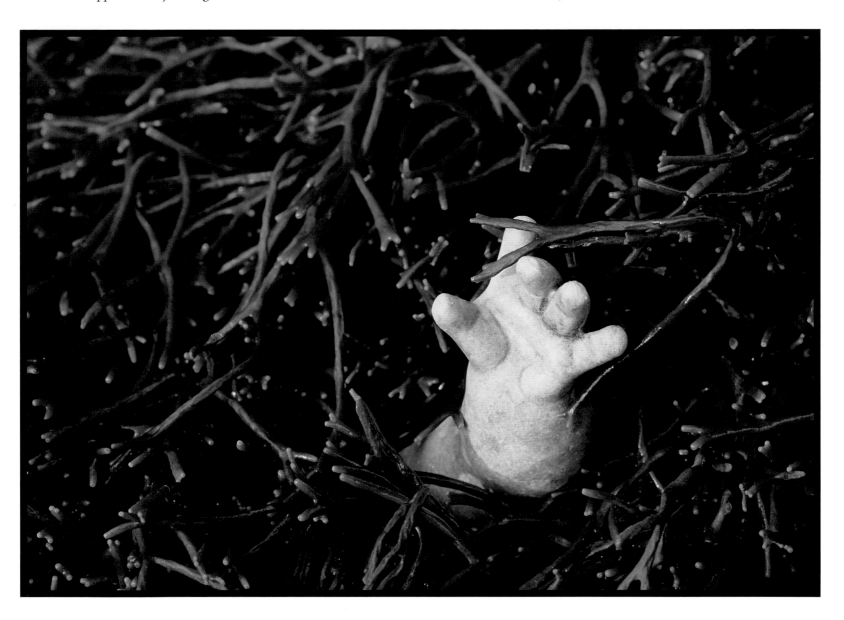

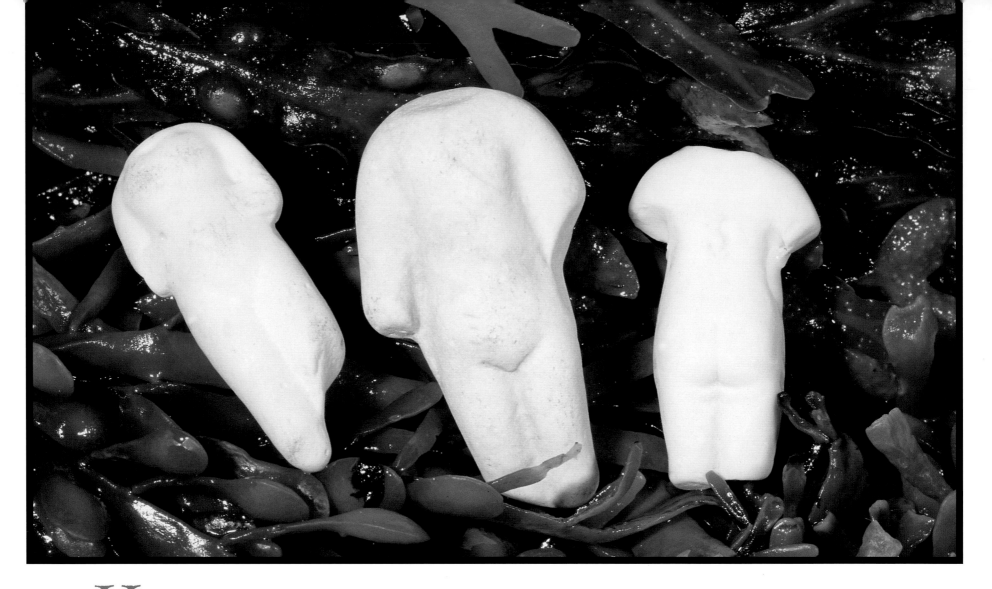

Known as Frozen Charlottes, these tiny figures were once given away as premiums in products such as flour and sugar.

There are two theories about the origin of their name. According to one, the dolls were so named because they have no jointed limbs. A second, more romantic theory links the dolls with a popular American ballad written by a blind wandering minstrel in 1833.

The song *Fair Charlotte* reveals the tale of a young lady who journeyed to a New Year's Eve ball with her fiancé, Charles. Charlotte was vain and refused to bundle up against the cold. According to the ballad, after a long, snowy ride to the ball, Charles extended his hand to help Charlotte exit the sleigh:

Then quickly to the lighted hall,
Her lifeless form he bore,
Fair Charlotte was a frozen corpse.
And her lips spake never more.

Alas, Charles died of a broken heart. Not coincidentally, perhaps, male dolls of the same genre are call Frozen Charlies.

Frozen Charlottes had many different names: teacup dolls, pillar dolls, penny dolls, and bathing dolls. Most had molded hair or bonnets, and their bodies—usually naked—were white, pink, or black.

Created from fine porcelain, these chubby, waterproof babies were thin and light. As a result, they could actually float or, as most children thought of it, swim. If a Charlotte was poorly designed or manufactured, it would tilt in the water.

When the trading vessel *City of Houston* sank off North Carolina's coast in 1878, its cargo included crates packed full of Frozen Charlottes. Imagine the confounding spectacle of hundreds of little Charlottes and Charlies, ranging in size from ½" to 5½", swimming toward Cape Fear.

The largest body in this group measures approximately 1¼" long.

ntil the Early Rennaissance, porcelain was thought to be a source of magic. In his sixteenth-century *Brief Account of Certain Excellent Things Known to the Ancients,* Italian author Guido Panciroli described porcelain as "a substance made of chalk, pounded egg, and the shells of sea-locusts, pressed together with other similiar things and hidden underground by the maker, who tells none but his children and grandchildren where it is. And they, eighty years later, dig it out and shape it into beautiful [objects]...."

Heir to centuries of mystery surrounding the recipe for making porcelain, this mid-nineteenth-century Frozen Charlotte has a surprisingly round belly.

This shard measures approximately ¾" long.

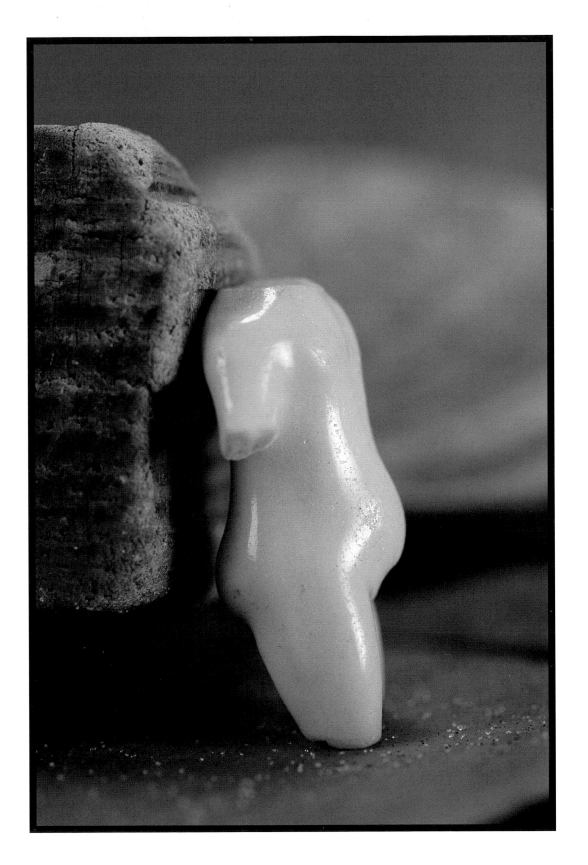

This angel probably came from a vase or bowl made by Wedgewood. The exquisite detail in the bas-relief figure is characteristic of Wedgwood's Jasper Ware, a nonporous pottery with raised detailing, created in 1775. The black coloring behind the figure is rare compared to the more popular blue, sage green, and lilac backgrounds.

This shard measures approximately 1⅞" by 1¾".

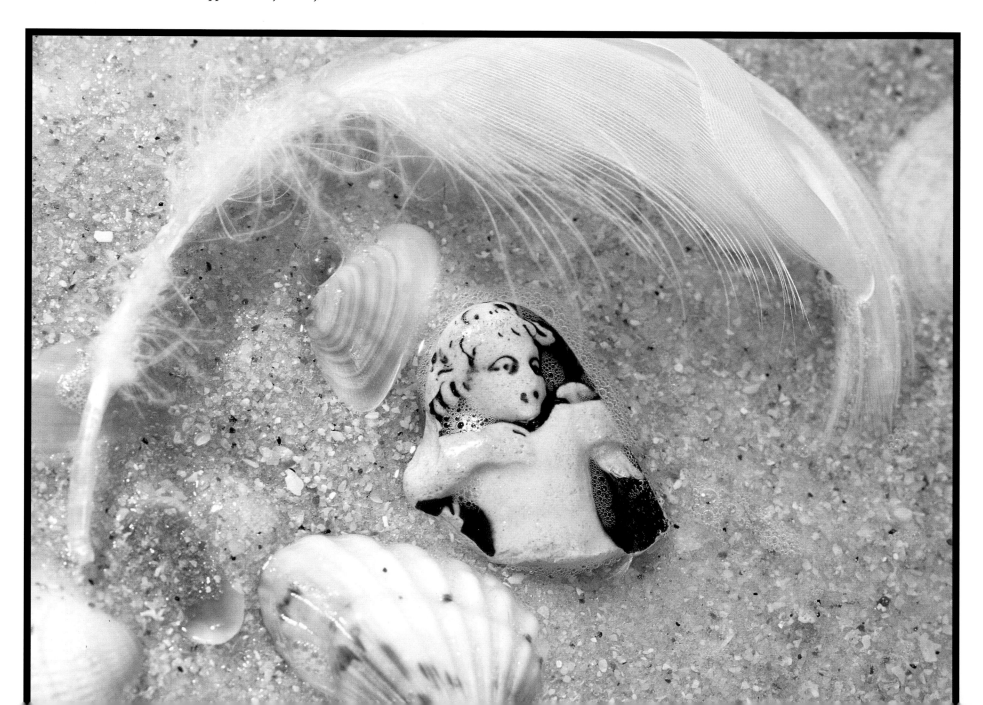

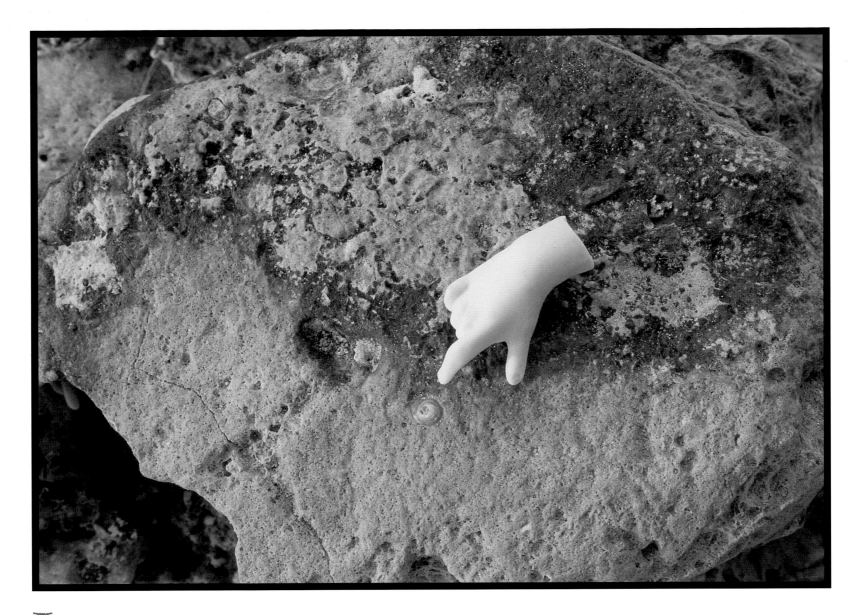

In the 1700s, European royalty, as well as the wealthy upper classes, decorated lavishly with porcelain figurines. Louis XV's Rococo style even caught on in China. In return the Chinese catered to European tastes at home and abroad—producing porcelain in substantial quantities and adopting European-style fashion in court society.

This piece of porcelain probably belonged to a figurine that sat atop a dining table or a mantelpiece.

This shard measures approximately ½" by 4¾".

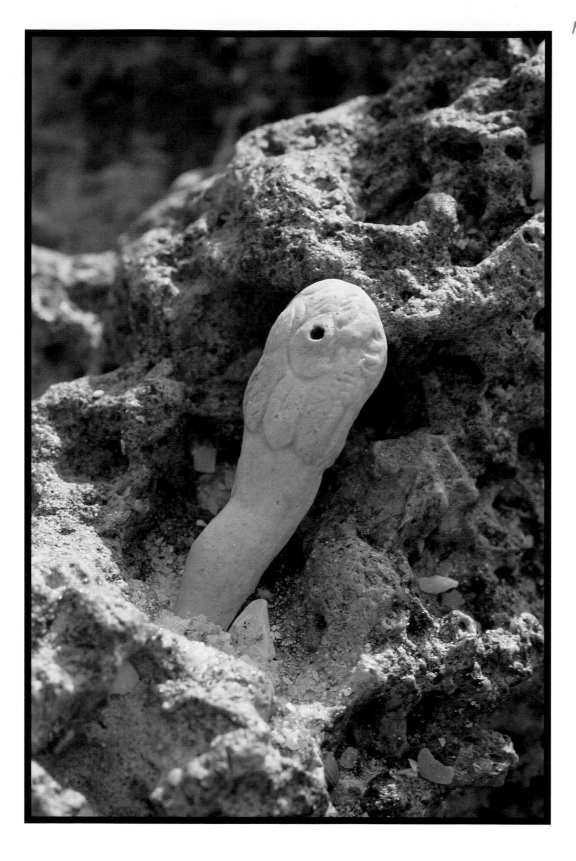

This miniature leg seems to be caught in a continuum of fact intersecting with fiction.

The Life and Strange Surprising Adventures of Robinson Crusoe, of York, Mariner, more commonly abbreviated as *Robinson Crusoe,* was written in the early 1700s. The novel's author, Daniel Defoe, traced the life of Crusoe, who was shipwrecked on an uninhabited island for twenty-four years.

Part of a nineteenth-century toy, this shard encountered a similar destiny as Crusoe, the legendary character after which the doll was fashioned. The ceramic leg washed up on a beach after at least a hundred years' worth of travel. In a collision of parable, parody, and neoclassic realism, no doubt the clay reproduction had brushes with both barbarism and civilization, as did Defoe's fictional character.

This shard measures approximately 1⅛" long.

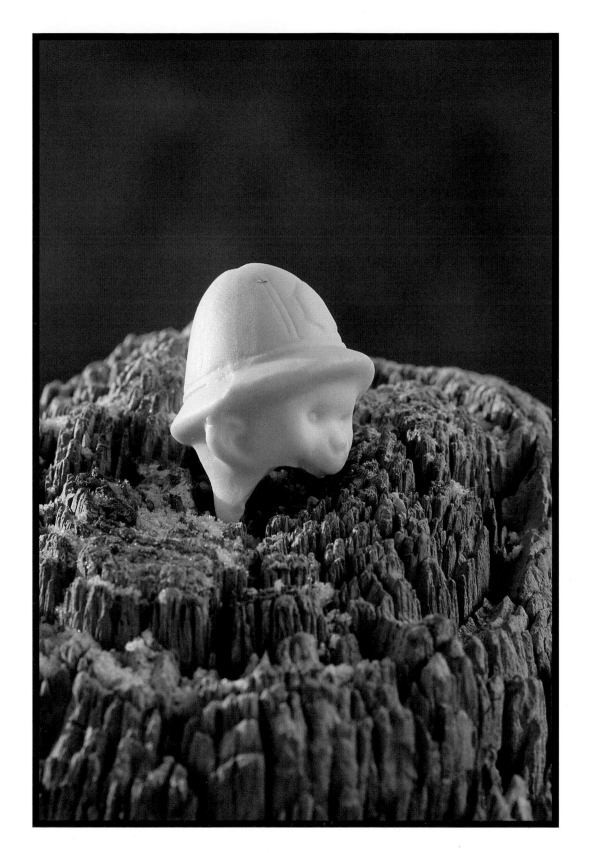

As if to provide comic relief, this hollow head joined the personae of the tidal zone. A mischievous facial expression, coupled with the English bobby's hat and its star, recall the undisciplined, irrational antics that characterized cinema's Keystone Kops.

Probably created in tribute to the early twentieth-century slapstick series, this doll-like ceramic shard is actually the top to a salt or pepper shaker.

The shard measures approximately ⅞" by ¾".

81

From the chubby baby leg to the adult limb complete with boot, the pinholes identify these as swiveling appendages from bisque toys. Some of these pieces once featured hand-painted accessories such as brown shoe soles, black boots, and white socks topped with blue bows. Like the mold-pressed boot buttons and shoelaces, the colors have long since worn away. The toes on at least one foot, however, are still delineated.

The largest shard in this group measures approximately 2" long.

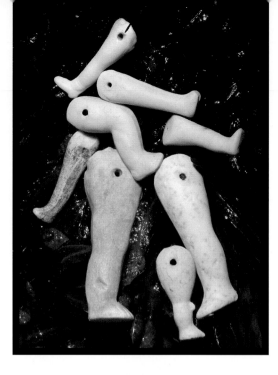

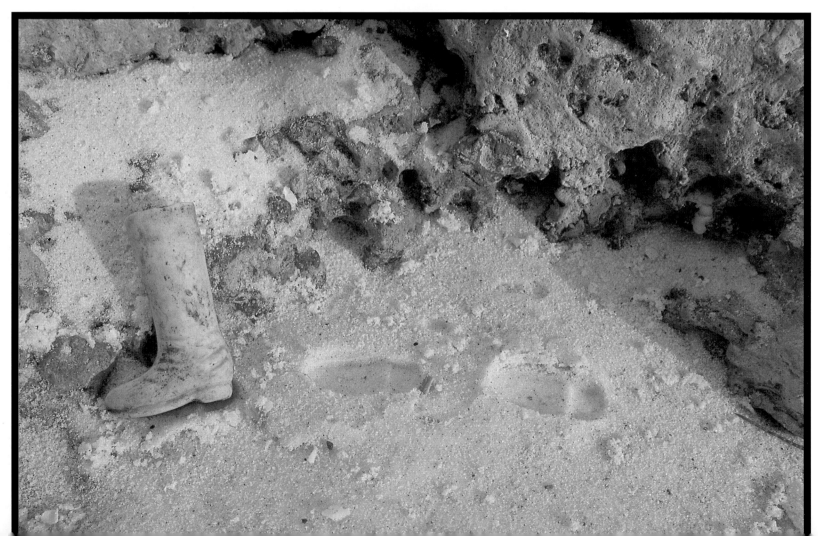

ight down to the tiniest arm, these shards reveal meticulous details such as fingernails, creases, and dimples. Some of those that are bent at the elbows belonged to Frozen Charlottes. Others, with shoulder holes, came from wire-jointed dolls. A third category of arm belonged to cloth-bodied figures, where wire, glue, or thread was used to attach each limb by means of grooves that encircled its base.

The longest arm in this group measures approximately 3" long.

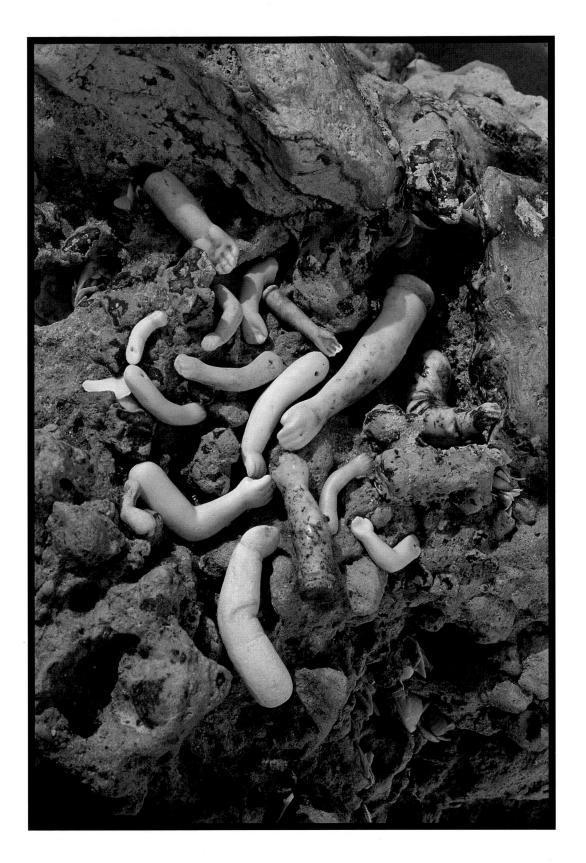

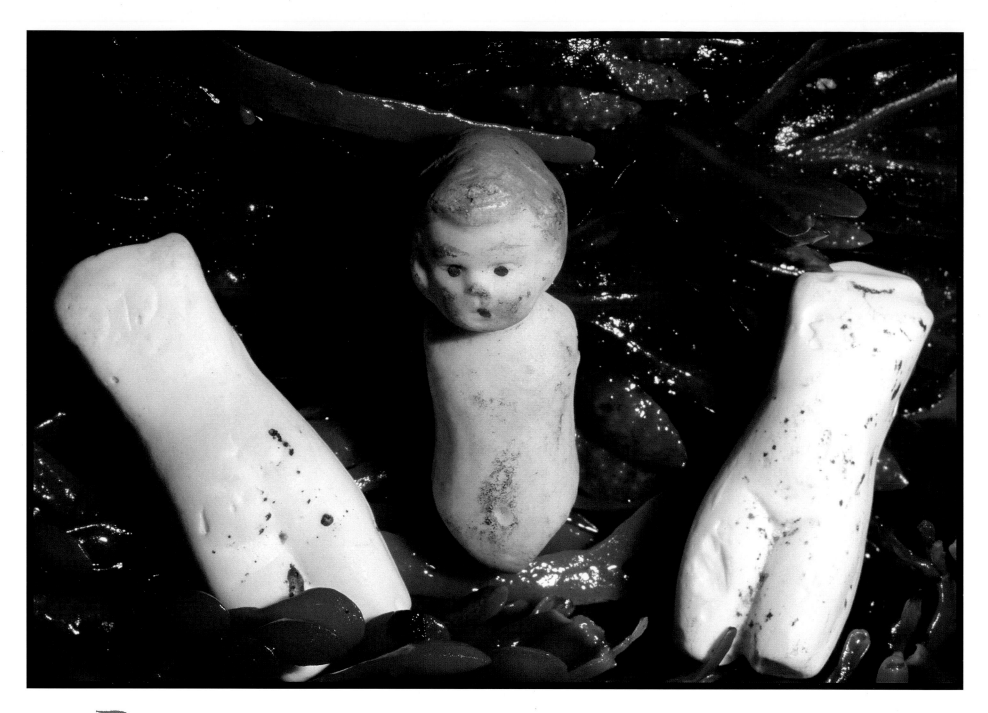

Probably mid-nineteenth-century German bisque, these dolls are similar to Frozen Charlottes, with the exception of arms and/or legs that swivel.

The largest in the group measures approximately 1½" long.

A story in the November 22, 1884, *Harper's Bazaar* commented on the volume and quality of dolls made by German factories:

"After being modeled by hand, they are baked in a great oven for a week. During this time the utmost care and watchfulness are required. The tenders are never permitted to sleep. A draught of air will produce disastrous results. A single oven contains 5,000 dolls, and thirty ovens are often full at once in one factory. At the end of the week the dolls come out in all conditions. About one in five is perfect. After baking, the dolls are painted and glazed. The imperfect ones are separated by themselves and sold to 'fairs' and 'cheap-John' concerns, which dispose of them to people who infest such places. One German factory has been running about one hundred and thirty years, and has produced about one billion dolls."

One of these two German doll heads has retained its hand-painted features. It was found on an inner-harbor beach where it probably drifted in with the tide, receiving less damage than it would have along an exposed, surf-washed coastline.

The larger shard measures approximately ½" by ¾".

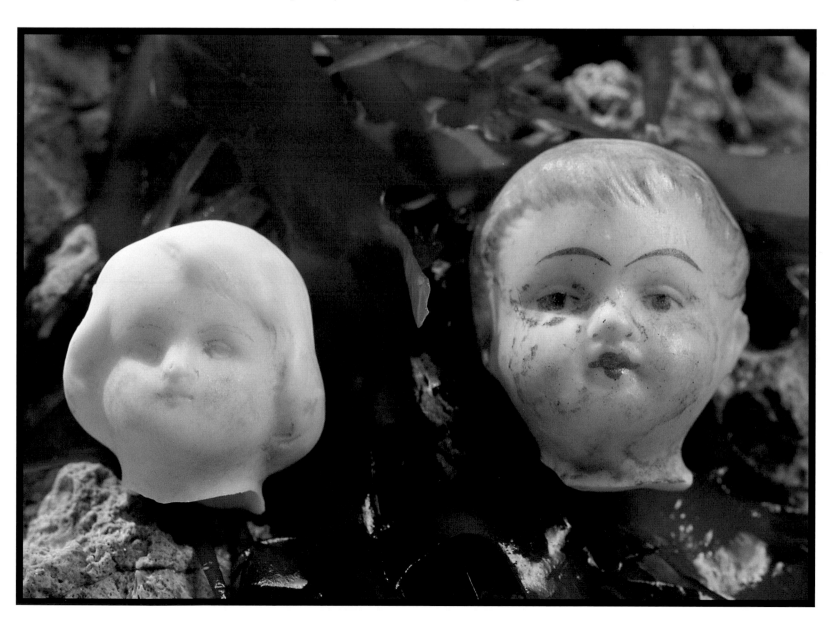

Pearl white and contoured, these ears mingle easily with ocean creatures. On the beach they might easily be mistaken for shells.

In the example below, the ear's large size, lifelike shape, and unglazed porcelain connect it to nineteenth-century France or Germany. The fine detailing suggests that it was made in a separate mold and then applied to the doll's head. Many ears of this type had pierced lobes to accommodate earrings.

This ear measures approximately ½" by 1".

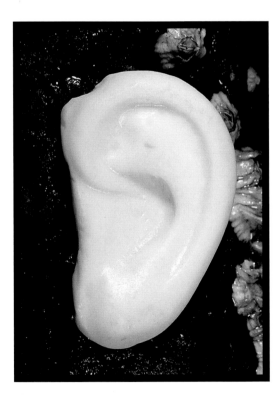

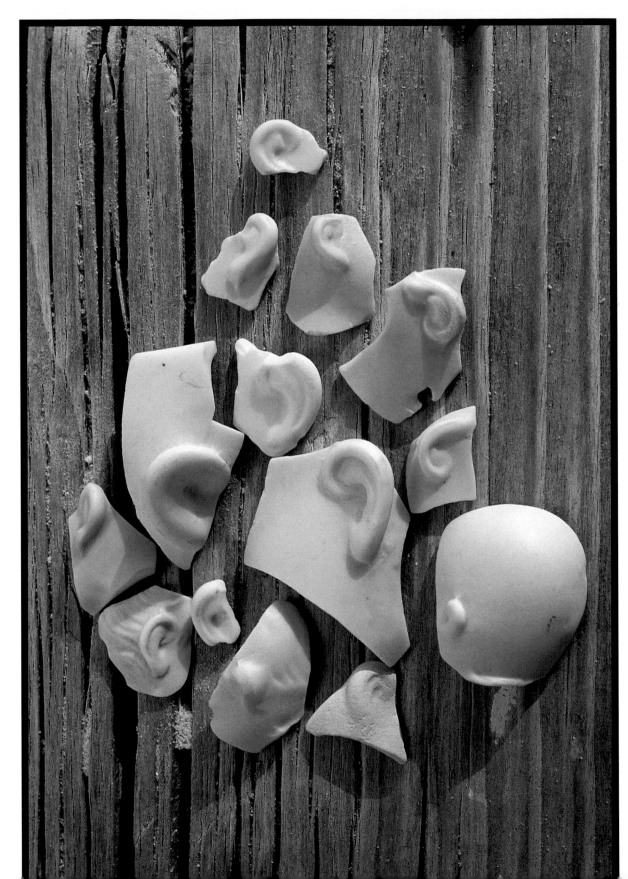

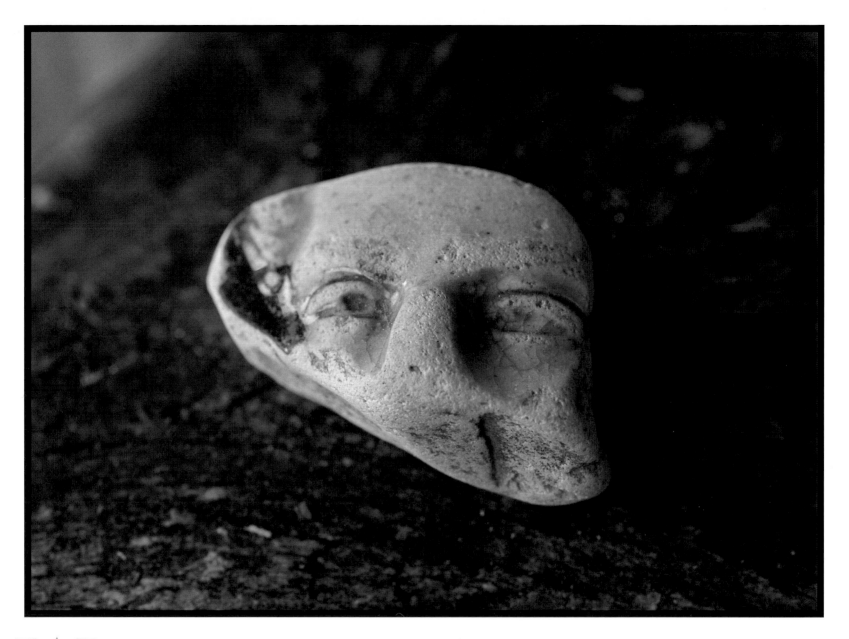

W hatever this apparition's origin, it recalls King Lear, Neptune, and other omnipotent figures. A strong brow and knowing, heavy-lidded eyes suggest a powerful presence even though this shard has been severely abraded by the elements.

This shard measures approximately ¾" by ½".

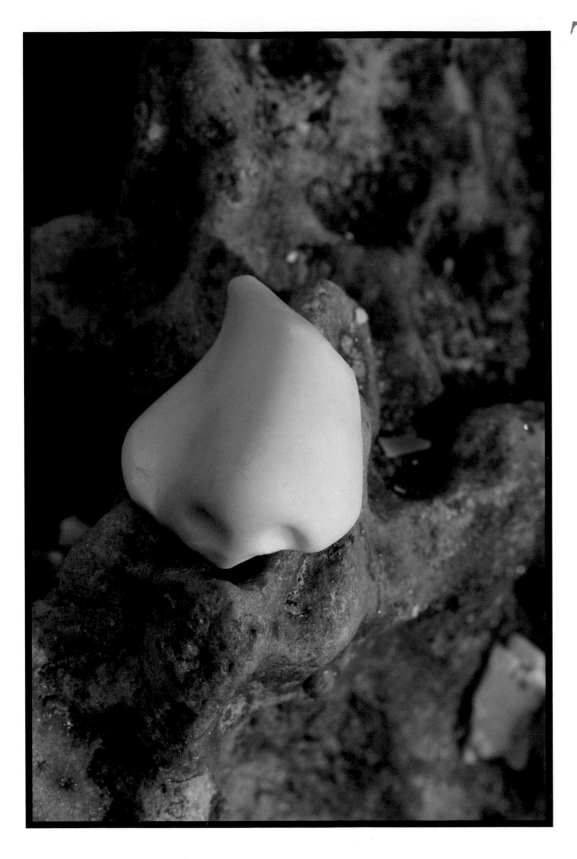

The shape and size of this delicately rendered ceramic nose suggest that it was made by one of the finer doll manufacturers in France or Germany. The two countries competed fiercely for the foreign doll market in the latter half of the nineteenth century.

In an illustration of the acrimony between manufacturers, the Jumeau doll factory in France included barbed commentary in some of its packaging. The "Letter of a Jumeau Baby to her Little Mother," part of a sixteen-page brochure, commented on the "... frightful German babies.... They are ugly and ridiculous enough, these German babies, with their stupid faces of waxed cardboard, their goggle eyes, and their frail bodies stuffed with hemp threads!"

Composed of bisque (unglazed porcelain) this aristocratic proboscis probably belonged to a boudoir doll from the mid-1800s. A doll this size often sat in an adult's bedroom—destined for decoration rather than child's play.

This shard measures approximately ⅝" by 1".

Of all the expressions captured by toymakers, this one conveys an engaging baby's pout. The pure innocence portrayed by such a doll was no doubt intended to be inviting to children.

Charles Baudelaire wrote in his essay "Morale du joujou" from *Le Monde Littéraire,* (1853): "All children talk to their toys; toys become actors in the great drama of life, which is reduced to the measure of the camera obscura of their little brains. Children demonstrate through their games their great talent for abstraction and their enormous imaginative power.... This facility with which children satisfy their imagination is a token of the spirituality of their artistic concepts. The toy is the child's initiation into art, or rather it is his initiation into its practical application, and when he has come to man's estate no perfect work of art will ever arouse in him the same warmth, or the same enthusiasm, or the same confidence."

This shard measures approximately ¾" by ½".

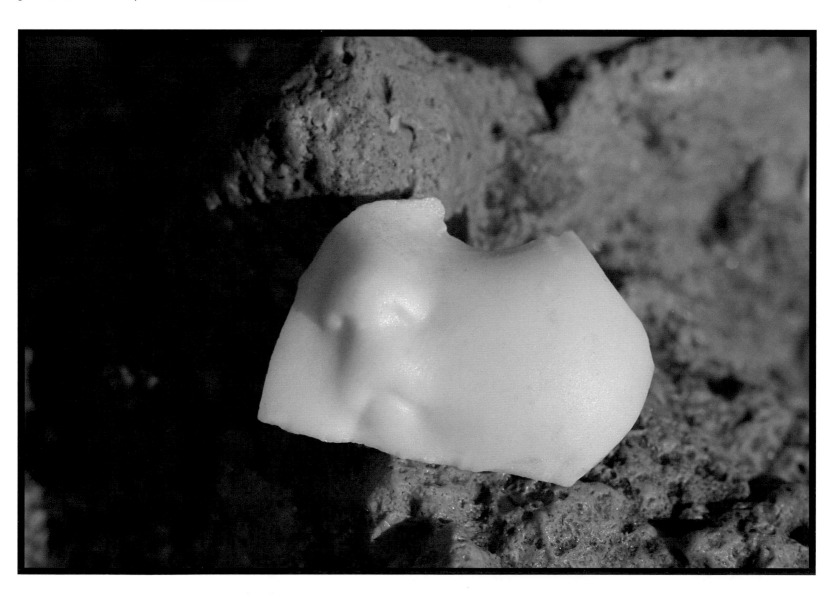

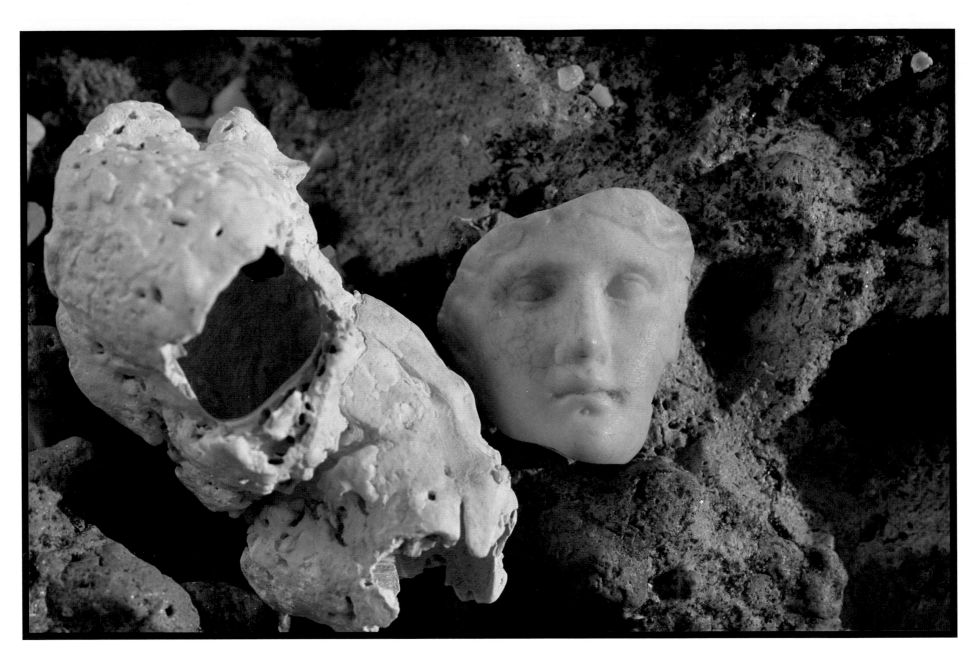

Most ceramic heads and faces lose their noses during their ocean travels, but this rare piece has retained all its features. In addition to the figure's prominent proboscis, the curled hair that sits low on the forehead recalls early statues of Helen of Troy, the Venus de Milo, and Mercury.

This shard measures approximately ¾" by 1".

This elephant's leg probably belonged to a German statuette dating from the mid-1700s. Measured to scale it matches a complete figurine in London's British Museum: Three chinoiserie holy men sit atop a pachyderm. This celadon green decorative piece, made in Meissen, Germany, stands on an ormolu, or gilded bronze base.

This shard measures approximately ⅞" long.

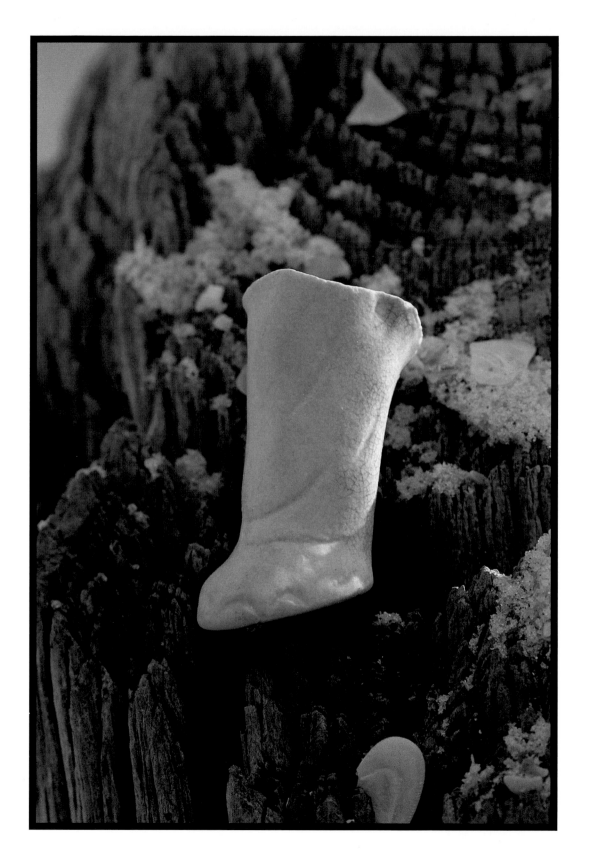

91

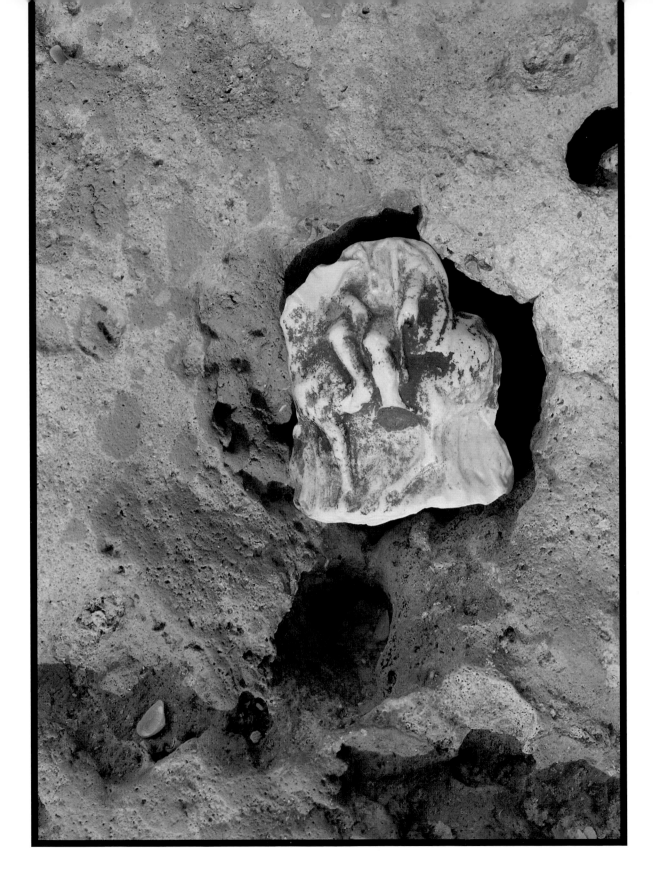

Just as Washington Irving's headless horseman still haunts the pages of "The Legend of Sleepy Hollow," this decapitated figurine has emerged eerily from another century. The ceramic statuette survived Nature's tortuous aquatic journey but not before losing its painted detail and glazed exterior.

The icon's smoothed, scarred surface leaves its identity open to interpretation. On the beach it appeared to be a lump of errant concrete. But closer examination revealed a man—perhaps a statesman, nobleman, or civic hero seated sidesaddle on a horse.

Another enticing possibility would be Dick Turpin. Celebrated in ballads and legend, the English highwayman lived in the early eighteenth century. Turpin rode the improbable distance from London to York in one night, establishing an alibi that freed him from murder charges.

London's Victoria and Albert Museum houses a similar figure of Dick Turpin, made around 1850 in Staffordshire.

This shard measures approximately 1⅞" by 1¼".

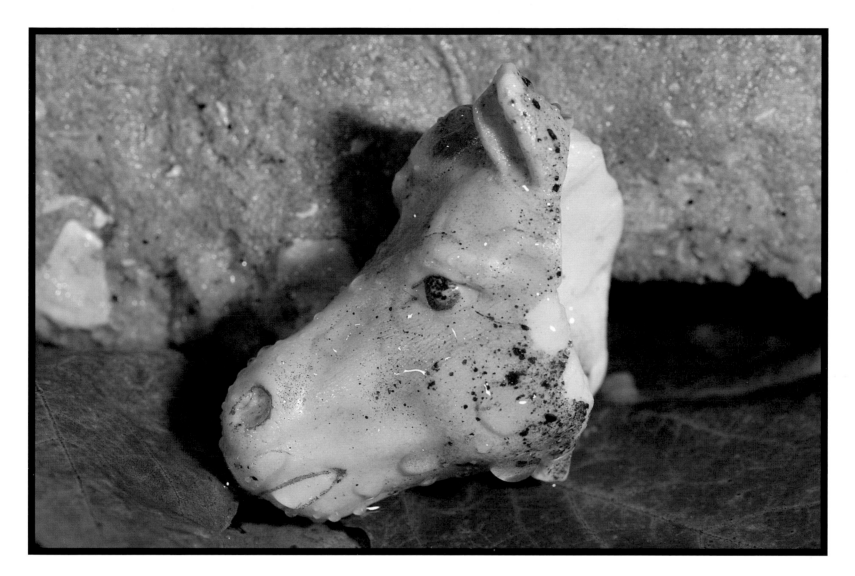

The dreams of a young horse fancier must have been shattered with the loss of this valiant steed. The remarkably detailed shard might have been a toy or figurine made of a hard ceramic.

This shard measures approximately 1" long.

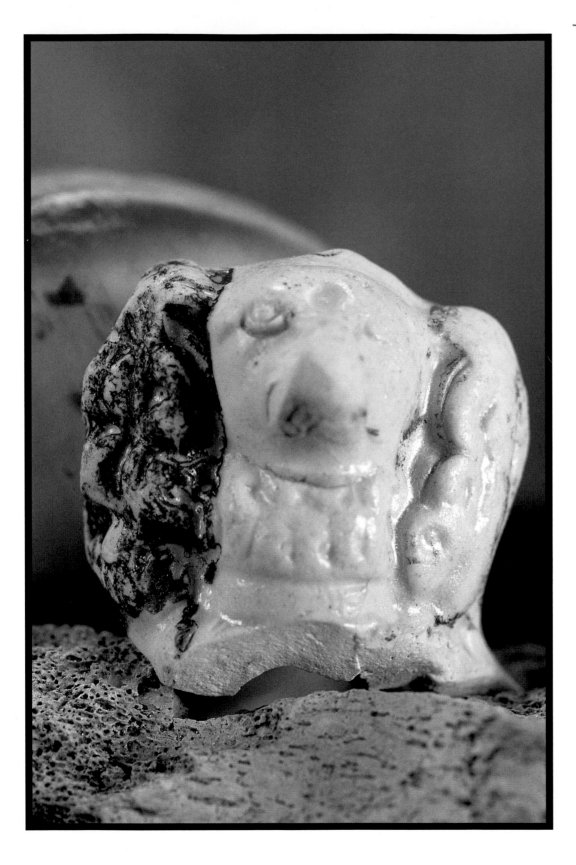

While much of this shard's detailing has been worn smooth, a smattering of paint helps clarify its identity. The high-set, rust-colored ears are characteristic of the head of a ceramic King Charles spaniel.

Staffordshire potters quickly capitalized on the national fervor for this breed. Not only were the dogs fashionable because they were long favored by English royalty, but they were also bred as companion dogs.

Potters made numerous versions of the King Charles spaniel, from miniature to life-size. During Victorian times the figurines were placed throughout salons, whether or not a real spaniel lived in the house. The best known devotee of the breed, King Charles II, whose name these dogs now carry, reputedly preferred their company to that of his courtiers.

This shard measures approximately 1½" by 1".

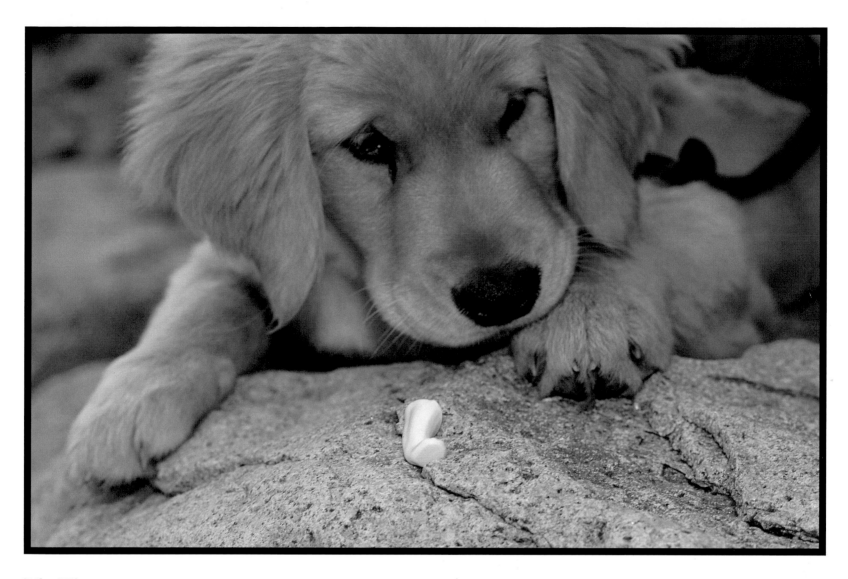

Here on a New England granite ledge, a golden retriever named Polar Bear discovers a piece of porcelain. The shard's detailed paw, including the dewclaw, help identify it as part of a nineteenth-century German canine figurine.

This shard measures approximately ¾" long.

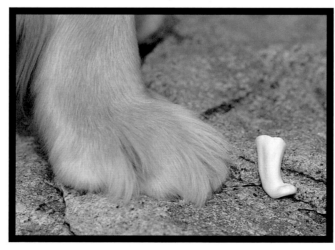

Epilogue

Why are we drawn to the coastline? In part, no doubt, the brine that hangs in the air and the rhythmic crashing of waves dispense eco-therapy. The sea is surely Nature's most potent antidepressant.

Some anthropologists point to sodium, potassium, and calcium, whose ratio in seawater is the same as that in human blood and bones. Maybe, with apologies to Herman Melville, beachcombers are just searching for their souls, which lie nearby in the ocean. To be sure, there is something primordial in it all.

And what of the broken relics we treasure? These salt-bleached artifacts pass by the world's coastlines like nomads on a voyage. Caught in a perpetual cycle, jitterbugging with the tide, heaved ashore only to creep back oceanward, sea glass promises a historical odyssey to those who choose to listen.

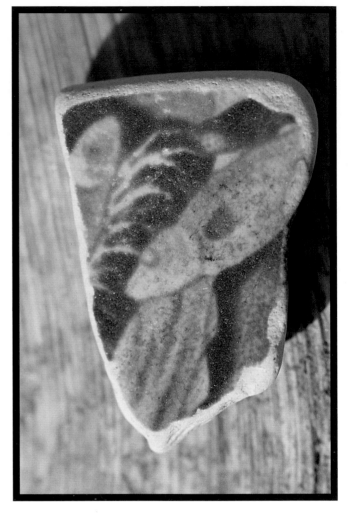

This shard measures approximately 1½" by ¾".